EMMA RICHARDSON CHERRY (1859 - 1954):
HOUSTON'S FIRST MODERN ARTIST

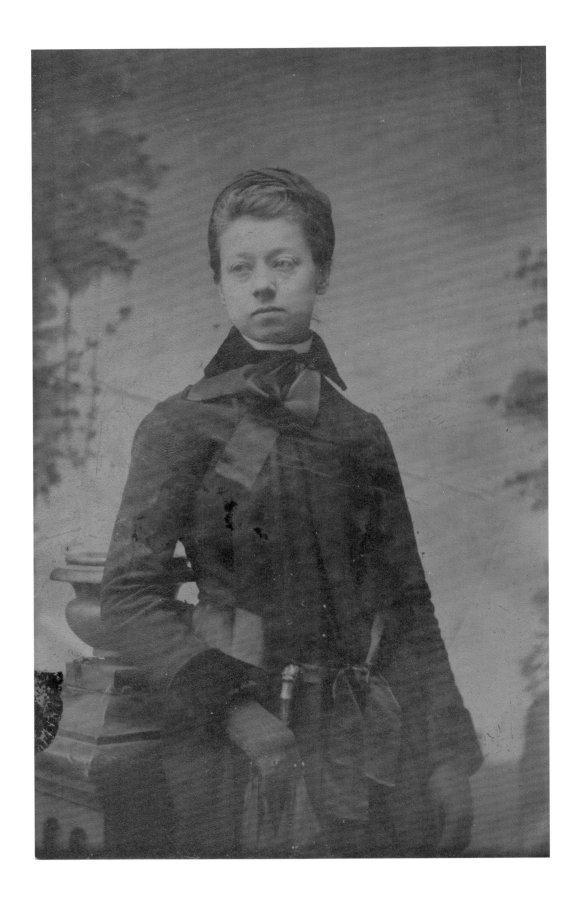

Published in conjunction with the exhibition *Emma Richardson Cherry: Houston's First Modern Artist*
Organized by the Houston Public Library. Curated by Danielle Burns and Randy Tibbits.

The exhibition is generously supported by the Houston Public Library, the City of Houston and the Houston
Public Library Foundation.

Houston Public Library
February 1, 2013 - May 4, 2013

Published by
Houston Public Library
500 McKinney
Houston, Texas 77002
www.houstonlibrary.org

In cooperation with
Bright Sky Press
2365 Rice Blvd.
Suite 202
Houston, TX 77005

Produced by Danielle Burns

Essays by Loraine A. Stuart & Randolph K. Tibbits

Edits by Jennifer Doyle & Houston Public Library

Design and layout by DMJStudio Detroit, Michigan

Library of Congress-in-Publication Data on file with publisher.

ISBN: 978-0-615-77158-8

Front Cover: Emma Richardson Cherry, *Decoration*, Oil on Canvas, 18 x 20, 1920s. Collection of Juli and Sam Stevens.
Back Cover: Emma Richardson Cherry, *Study in Compositional Spaces*, Oil on board, 12 x 8 ½, 1925.
Collection of Randy Tibbits and Rick Bebermeyer.

Printed in Canada by Friesens

EMMA RICHARDSON CHERRY (1859 - 1954):
HOUSTON'S FIRST MODERN ARTIST
February 1, 2013 - May 4, 2013
Houston Public Library | Julia Ideson Building
550 McKinney, Houston, TX 77002

Emma Richardson Cherry (1859 -1954) came to Houston in the mid 1890s and remained a Houstonian for almost sixty years. Through her work as a teacher, lecturer, civic organizer and professional artist, she helped shape the art environment of the city and of Texas. Almost single-handedly at first, she laid the foundation upon which Houston would later build a vibrant art culture. She was a vital conduit, bringing current ideas from the greater art world to a small town of fewer than 30,000 when she arrived, and which still fell far short of a million when she died in 1954.

As one of the first women and one of the first Americans of either sex to paint at Giverny in 1888/89, Cherry arrived in Houston with first-hand knowledge of Impressionism. Soon after her arrival she mounted the first Impressionist exhibition in Texas. As a result of her encounter with artists Marsden Hartley and Stuart Davis in Gloucester, MA, and as one of fewer than one hundred members worldwide (and the only one from Texas) of the international avant-garde Société Anonyme in New York in the early 1920s, she was exposed to the concepts of fellow members Marcel Duchamp and Man Ray among others. These contacts enabled her to put Houston in touch with the most advanced art ideas circulating at the time. And after study with Cubist painter Andre Lhote in Paris in 1925/26, she painted what are likely the first Cubist paintings by a Texas artist.

Cherry was one of Houston's first modern artists. She, her students and their students (for as one commentator said "all that Mrs. Cherry does comes back to us, for when she is not creating she is imparting") formed a core of forward-looking artists in the city decades earlier than is generally recognized. Newly discovered paintings and documents now make it possible to tell and illustrate the story of her amazing accomplishments.

CONTENTS

FORWARD

It is my privilege and honor to present the first exhibition catalog published by the Houston Public Library, *Emma Richardson Cherry: Houston's First Modern Artist*. As an outspoken arts advocate, educator, and civic organizer who influenced generations, Emma Richardson Cherry was ahead of her time. This exhibition and catalogue place her life and career into a new context through recently discovered paintings and documents. That the exhibition takes place in the galleries of the Special Collections Library in the Julia Ideson Building has special significance as Cherry's own murals adorn our walls.

The Houston Public Library's mission to enlighten generations about historic and present-day Houston could not be better served than through our presentation of this exhibition. We are confident that it will stimulate understanding, enjoyment, and pride amongst our audiences. The indispensable role that our exhibitions play in the educational development of Houston helps us discover who we are and understand our relationship to each other and to society. Most importantly, with this exhibition and catalogue the Houston Public Library continues Emma Richardson Cherry's commitment of presenting art and culture to an eager audience.

We are enormously grateful for the generosity of our lenders without whom the exhibition and catalogue would not have been possible. The Gayden Family Foundation is a strong supporter of scholarship about early Texas artists. Their matching grant contribution enabled us to secure the money to fund this catalogue, our gratitude is immeasurable. To the many who contributed anywhere from ten to one thousand dollars, thank you. We would also like to thank the Houston Public Library Foundation, who has been our partner in this endeavor, for their enthusiastic support of this project.

It is a pleasure to credit my colleagues at the Houston Public Library who have contributed their talents to this project: Danielle Burns, Curator, whose energy and efforts were key in bringing this idea to fruition; Meller Langford, Deputy Director; Roosevelt Weeks, Deputy Director; Greg Simpson, Assistant Director of Communications and the entire Communications Division. Special thanks to co-curators Randy Tibbits, scholar of early Houston art , and Lorraine Stuart, Museum of Fine Arts, Houston, Archives Director for sharing their knowledge and insight.

Most of all, we are grateful to Emma Richardson Cherry for sharing her gifts with Houston and beyond.

Rhea Brown Lawson, MLS, Ph.D.
Director, Houston Public Library

PREFACE

Shortly after the inaugural exhibition of the newly renovated Julia Ideson Building, I met with Randy Tibbits, Rice University Librarian and scholar in early Texas Art, and Bill Reaves, owner of William Reaves Fine Art. We discussed the possibility of staging an exhibition featuring some of Houston's early artists, collectively referred to as the HAG (Houston Art Gallery). During the meeting we discussed the histories and careers of several artists, however, the conversation kept returning to "Mrs. Cherry."

I was thoroughly familiar with Mrs. Emma Richardson Cherry. Her Public Works Administration (PWA) murals adorn the walls of the Tudor Gallery in the Julia Ideson Building; I had been living and working with her art for several months. In our archives I found a collection of her personal notes and a few sketchbooks. Bill mentioned that a cache of some two hundred works by Mrs. Cherry had been recently discovered by her descendants. To my great delight there was enough material to do a show.

A retrospective of Cherry's work had previously been done. In 2004, the Heritage Society of Houston exhibited *Actively Working, Silently Waiting: The Paintings of Emma Richardson Cherry*, which examined her career during the sixty plus years she worked, studied and taught art in Houston. While acknowledging this well-received exhibition, we wanted to present Cherry's work in a context reflecting current ideas and issues concerning the nascent field of regional Texas art. In doing so, we felt that the 1920s Spanish Renaissance building in which Cherry's murals were housed would provide the perfect setting.

Emma Richardson Cherry's oeuvre was extensive. She created figure studies, Texas landscapes, and still lifes in oil, watercolor, and pastel. Mainly known for her flowers and portraits, Cherry also produced a body of little-known modernist painting. She was exposed to French avant-garde art during extensive travels in Europe, where she absorbed new arrangements of form, color, and line. Cherry brought artistic innovations in technique and subject matter to Houston through both teaching and practice.

Emma Richardson Cherry: Houston's First Modern Artist includes more than forty works by Cherry. Some of these reflect Cherry's modernist experiments while others are more traditional. Also included are more than twenty works by a select group of Cherry's students and contemporaries, many of whom are regarded as some of Houston's first twentieth century artists. The presentation is complemented through succeeding generations of artists to discuss the impact of Mrs. Cherry's work.

The publication of *Emma Richardson Cherry: Houston's First Modern Artist* and the exhibition it accompanies are the products of careful planning, cooperation, and knowledge from several dedicated individuals. Randy Tibbits, co-curator, meticulously collected and documented Mrs. Cherry for years. His level of scholarship is demonstrated by the caliber of the exhibition and its catalogue.

Randy's knowledge about Cherry coupled with my curatorial eye was a match made in heaven. Lorraine Stuart, Archives Director at the Museum of Fine Arts, Houston, wrote a beautiful essay about Emma Richardson Cherry and her civic duties in Houston, Texas. Lorraine's research revealed Cherry to be not only a thoughtful artist, but also an astute civic leader who spearheaded the organization which later became the Museum of Fine Arts, Houston.

I would like to express appreciation to the Houston Public Library administration whose support made this exhibition possible: Director of Libraries, Dr. Rhea Brown Lawson; Deputy Directors Meller Langford and Roosevelt Weeks; and Greg Simpson, Assistant Director of Communications. Thanks are also extended to all the lenders and donors. We are especially grateful to the Gayden Family Foundation whose matching funds grant allowed us to produce this catalogue.

Danielle Burns
Curator, Houston Public Library

ACKNOWLEDGEMENTS

I would like to thank the Houston Public Library administration for their support throughout this project, Director of Libraries, Dr. Rhea Brown Lawson, Deputy Directors Meller Langford and Roosevelt Weeks and Greg Simpson, Assistant Director of Communications.

Many thanks also extended to the entire Communications Division for their tireless support; Veronica, Vick, Antonio, Ralph, Franchella and Belinda, you are the best. I appreciate the assistance of the Houston Public Library Foundation for managing our finanaces for this catalogue. I was also pleased to work with Jennifer Doyle for her careful editing, Donna Jackson, the designer, for her clear vision of how she wanted the catalogue to look and Bright Sky Press who helped us through the publishing process. Many thanks to Joseph Newland for his expertise in the publishing field and his reassuring words," it's going to be okay." Special thanks to interns Elizabeth Kline and Ciaran Finlayson for their help in the beginning stages of this project and Christina Grubitz for volunteering so many hours and for helping to see this project through.

Of course, Randy Tibbits and Lorraine Stuart, it has been a pleasure. I cannot wait to work on another project with you both. I thank all of the lenders and donors that really made this exhibition and catalogue possible. Thank you Bill Gayden, you truly are a blessing and I thank the Gayden Family Foundation.

Finally, I would like to thank my amazing family and friends for their continuous support. I love you all.

Danielle Burns

I would like to thank my husband, Rick Bebermeyer, for his patience and support over the years even as Emma Richardson Cherry became almost a third member of our household; Bill Reaves, of William Reaves Fine Arts, for his encouragement in this and countless other efforts on behalf of Early Texas Art; Danielle Burns, Houston Public Library Curator, who enthusiastically embraced this exhibition proposal even though it must have seemed a little crazy to her at first; and the Houston Public Library for providing a beautiful venue in the Ideson gallery where we could reintroduce Emma Richardson Cherry to Houstonians. I would also like to thank all the donors and lenders without whom this exhibition dream could not have become a reality.

Randy Tibbits

Special thanks are due Museum of Fine Arts, Houston Director, Gary Tinterow, and Curator of American painting and sculpture, Emily Ballew Neff. Gratitude is also extended to museum colleagues Maite Leal, Paintings conservator; Sarah Shipley, Digital archivist; and Photographic and Image library staff Thomas R. DuBrock, Veronica Keyes and Marcia Stein.

Lorraine Stuart

LENDERS TO THE EXHIBITION

Sam and Neil Akkerman

Torch Energy Collection

James Clement

Rie Davidson Congelio

David Dike Fine Art

Cynthia and Bill Gayden

The Heritage Society at Sam Houston Park

Houston Public Library

Tam and Tom Kiehnhoff

David Lackey and Russell Prince

Sandra and Bobby Lloyd

Larry Martin

Wade Mayberry

Museum of Fine Arts, Houston

Bobbie and John L. Nau

Jennifer Reid & Zachary Patton

William Reaves Fine Art

Linda and Bill Reaves

Mr. and Mrs. Romero

Juli and Sam Stevens

Randy Tibbits and Rick Bebermeyer

Earl Weed

Nancy and Otis Welch

Private Collection

SPONSORS FOR THE EXHIBITION CATALOGUE

The Gayden Family Foundation

Gertrude Barnstone

Claire Bond

Bonnie Campbell

Bill Cheek

Rie Davidson Congelio

Lady Washington Chapter, National Society Daughters of the American Revolution
(In honor of Emma Richardson Cherry - one of the chapter's first members)

Kate Robinson Edwards

Leila and Henri Gadbois

Jo Frances Greenlaw

Geralyn and Mark Kever

Tam and Tom Kiehnhoff

David Lackey Antiques

Larry Martin

Masters Fine Art Conservation

Carl McQueary

John & Barbara Nau

Beverly and George Palmer

Jennifer Reid-Patton

Stan Price

Linda and Bill Reaves

Williams Reaves Fine Art

Shirley and Don Rose

Sue and Lee Rose

Richard Stout

Texas Art Collectors Organization (TACO)

Randy Tibbits & Rick Bebermeyer

Nancy and Otis Welch

EMMA RICHARDSON CHERRY: A LIFE TO BE LIVED

by Lorraine A. Stuart

Between 1900-1925, the number of art museums in the United States increased dramatically. The new museums, often organized by ordinary citizens interested in engaging the public in the arts, were an outgrowth of the Progressive Reform Movement. In Houston, this turn-of-the-century "grassroots" movement was embodied by the Houston Art League, the founding organization of the Museum of Fine Arts, Houston (MFAH). In *A Brief Review of Art Progress in Houston,* Stella Hope Shurtleff wrote, "the League bears the imprint of strong personalities so... that [its] story might be told in a series of biographical sketches. Perhaps the highest tribute that can be paid to those who are responsible [is that it] can be told without mention of their names."[1] Shurtleff's sentiment is likewise a testament to the Progressive ideals which gave rise to the League and which were held dear by its members. The cast of "strong personalities" is extensive and includes Roberta Lavender, founding member and future Dean of Women at the University of Texas at Austin; Mrs. Robert S. (Lavinia Abercrombie) Lovett, founding member and first League president; Florence Fall, League president from groundbreaking through opening of the first museum building; Rabbi Henry Barnstein, long-term board member and civic leader; Margaret Holland, League president and first female physician to practice in Houston; Annette Finnigan, businesswoman, art patron and suffragette; and Stella Hope Shurtleff, art scholar and lecturer, along with a multitude of other League members. Among them, Emma Richardson Cherry (1859-1954) is arguably the single most instrumental figure in the establishment of the Houston Art League.

An artist and educator, Cherry's advocacy for the arts reflected the principles of the Progressive Movement. Many of these social reformers believed that the study of art, literature and music as well as urban beautification would have a stabilizing effect on the American social structure, which had been buffeted by waves of immigration. Primarily comprised of females, the progressives were also associated with the women's suffrage movement. The League's ties to the Progressive Reform Movement are reflected in their membership's participation in the reform-minded clubs of the day. For Cherry, these included the Girls' Musical Club - now known as the Tuesday Musical Club – that helped form the Houston Symphony Orchestra; the Houston Symphony Society; the Rusk Settlement; the Ladies Reading Club; the Chautauqua Society; and the Houston League of Women Voters.

Singular to Cherry was her prior experience in the founding of similar arts leagues. While living in Kansas City in 1887 she founded a Sketch Club which is now the Kansas City Art Institute and School of Design. Cherry then moved to Denver where she organized the Denver Artists Club (1891) which evolved into the Denver Art Museum (1922). Although she left Denver for Houston in the mid-1890s, she maintained close ties with the museum and art community there. In Texas, she became a charter member of the Texas Fine Arts Association, served as director of the Elisabet Ney Museum in Austin, and was invited to assist in the organization of the San Antonio Art League. In 1920, she joined Société Anonyme, founded by Marcel DuChamp, Man Ray, and Katherine Dreier. This move revealed the depth of her interest in the contemporary art being created in New York and abroad.

Also distinguishing Cherry from other Progressive reformists is the depth of her artistic studies and her career as an artist and art instructor. Having begun her career teaching art at the University of Nebraska in her twentieth year, Cherry taught for most of her life. She studied briefly in Chicago and intermittently in New York at the most progressive art school of the era, the Art Students League, with instructors William Merritt Chase, Kenyon Cox and Walter Shirlaw. Cherry maintained ties with the Art Students League the remainder of her life.[2] In 1888, she embarked on the first of several trips to Europe. There she studied at the Académie Julian in Paris with Jules

Joseph Lefebvre. On a return trip to Europe, she studied with André Lhote at the Académie Merson. While living in Colorado, Cherry taught briefly at the University of Denver. In Houston, she operated a studio school for more than thirty years at the historic home now preserved by the Heritage Society as the Nichols-Rice-Cherry house.

In a 1917 account, founding League member Roberta Lavender recounted that "It was largely through the influence and through the work of Mrs. Cherry that the League was launched in Houston."[3] In 1931, Cherry was given a solo show at the museum - which had opened its first permanent building in 1924 - commemorating her contribution to the Houston art community. The same year the board passed a resolution honoring her role in the founding and development of the museum. Despite these accolades, evidence of her influence remains less documentary than circumstantial. Time and again, Cherry had prior associations with the people, places, and institutions that exerted influence on the League and its formation.

By all accounts, the speech presented by Jean Sherwood "to a number of ladies and two gentlemen" in the home of Mrs. Robert Lovett on March 17, 1900[4] was the immediate catalyst for the formation of the Houston Art League. Sherwood had been invited to speak in Houston by Roberta Lavender and a number of her fellow teachers who had heard her speak at the Colorado Chautauqua in Boulder in 1899. Sherwood, a member of the Chicago Public School Art Society, organized exhibitions installed at the Art Institute of Chicago (AIC). The *Houston Daily Post* provided this account of her speech for the Chautauqua meeting:

> "Mrs. Sherwood spoke eloquently on the value of art studies in the development of fine character and spiritual beauty. President of the Chicago Art Decoration society organized for the purpose of beautifying the school rooms and public halls, the lecturer made all feel that public schools should have parks and interior decorations if we would cultivate the taste of the child, all these forms of beauty appealing to the aesthetic emotions."[5]

The "Summer Resort Notes" in the *Dallas Morning News* places Cherry at the Colorado Chautauqua that summer. Cherry also lectured at the Chautauqua meeting prior to 1897, possibly during the time she lived in Denver. Cherry had studied briefly in Chicago prior to 1878[6] and had exhibited at the AIC four times between 1891 and 1902.[7] She also traveled to the city to paint portraits in 1899.[8] Whether their association began in Chicago or Colorado is uncertain; it is known that in the days preceding the meeting, Cherry "laid the plan [for an art league] before her . . . With [Sherwood's] encouragement, Mrs. Cherry obtained permission of Mrs. R.S. Lovett to hold the first meeting at her home."[9]

From 1900 - 1913, the League operated under the name the Houston Public School Art League and placed reproductions of art objects in the city's schools to further art education. From 1900 - 1904, 136 reproductions were placed in the city schools.[10] Cherry was the first to chair a committee central to these efforts, which operated under the misnomer, the Censorship committee. In 1906, she proposed to augment the reproductions with original works, "her own, and others she could procure."[11] The same year, Cherry, who shared with the Impressionists an enthusiasm for Japanese art, donated a set of Japanese prints and organized an event highlighting Japanese art and culture at the Fannin School. [12]

In 1913 the Houston Public School Art League incorporated under the name the Houston Art League. This change

reflected the broader mission the League had embraced: to introduce traveling exhibitions to the city's general populace and to create a permanent museum building with an art collection. Two works were purchased "as a nucleus for Houston's permanent collection of paintings"; one of these was the *Old Violinist* by American artist, Charles Curran. Curran had also studied under Jules-Joseph Lefebvre at the Académie Julian, which suggests that Cherry had knowledge of his work and may have exerted influence over its acquisition.

The majority of works that entered the permanent collection during the Houston Art League years were bequeathed by George M. Dickson. Among the artists otherwise represented in the collection were Birger Sandzen, whose work was purchased outright by the Cherrys, and Alexander Robinson, who had likewise studied at the Académie Julian. When the museum opened in 1924, Cherry spearheaded a drive to purchase *Aunt Jennifer's China* by Hilda Belcher. Documentation in the MFAH's art object file indicates the work was "bought by subscription by ninety-four citizens at the instigation of Mrs. D.B. (Emma Richardson) Cherry".[13] Cherry's influence, however, was exerted most in the areas of programming and exhibitions. The first known event hosted by the League was "Dutch Evening" held in 1902. Costumed participants recreated works by the Dutch masters, accompanied by music. Cherry made introductory remarks preceding each tableau. The idea for the tableau may well have come from the Art Students League. In recounting her experiences there, "She noted that one of the most successful affairs staged by the [Art Students League] was an evening of living pictures. 'Artists from the city posed the models chosen by the students who had planned the costumes and verily, the affair was an artistic success! This was in the attic at the Fourteenth Street location.'"[14] The "Dutch Evening" was followed by "A Night in Italy" in 1903.

A fifth of the exhibitions held between the founding of the League and 1925 were either curated by Cherry or associated with her in some regard. Exhibitions came from Colorado and Chicago. Other shows featured artists Alexander Robinson or her close friend, Dawson Dawson-Watson. Cherry herself was represented in an exhibition with Percy W. Holt in 1923 and in solo exhibitions in 1925 and 1931. She participated in an extraordinary twenty-six annual exhibitions, the last in her eighty-eighth year. In 1928, the MFAH hosted the Modern French and American Art exhibition featuring artist Marsden Hartley, for whom Cherry had a keen appreciation, as well as such artists as Arthur B. Davies, Raoul Dufy, Aristide Maillol, Rufino Tamayo, and Maurice de Vlaminck. The exhibition, organized by the Weyhe Gallery in New York City, traveled first to the Denver Art Association.[15] While there is no extant evidence documenting Cherry's role in bringing the exhibition to Houston, it is improbable that she would not have exerted her influence toward that end.

A Houston Chronicle article in 1925 assessed Cherry's exhibitions as the "weathervanes that showed which way the wind was blowing in the art development of the U.S."[16] In her career, both as an artist and arts advocate, Cherry strove to bring the national and international art scene to Houston. Her success in fostering an art community and in promoting the formation of the Houston Art League lay in her inherent appreciation for art, coupled with her view of art as a tool for social reform. Her message fell on the receptive ears of the city's progressives who, once the League was formed, likewise embraced a vision of art as more than a means to an end. Art became, as the motto of the Girls Musical Club stated, "not painting in water colors, or playing on the piano forte; it is life to be lived."

EMMA RICHARDSON CHERRY: HOUSTON'S FIRST MODERN ARTIST

by Randolph K. Tibbits

In October 1894 Emma Richardson Cherry was considering a move from Denver to Houston. Even though her husband, Dillin Brook Cherry, and their two year old daughter Dorothy had already made the move, Emma had stayed behind. Dillin, who had worked in railroading as a young man, saw his prospects in Denver decline after the panic of 1893 devastated the economy of the Western United States. He hoped that family connections in cotton brokerage and real estate development would open greater opportunities for him in Houston. But those opportunities were still only hopes.

Emma was already a well-trained and well-respected professional artist, having studied in New York and Paris before her move in 1889 to Denver, then a dynamic city of more than 100,000 people. Once there she energized the local art community, as was her pattern everywhere she lived: teaching, lecturing, founding art groups, using her national and international connections to bring works of art to the city for exhibition. She relished her life as an artist in Denver; but equally important for the survival of her family, in Denver she was able to earn money from her art.[1]

The separation from her daughter and husband was painful. Her mother and younger sister, Ruth, were in Texas to see after Dorothy, which made being apart a little easier. Though he longed for her to be with him, Dillin accepted the necessity of their situation. But all her close family – husband, daughter, parents, brothers, sister – now lived in the Houston/Galveston area. It was difficult to resist the pull, so she was thinking of a move.

When her brother James Perkins Richardson got wind of her plan, he wrote her a letter advising against it. A Yale graduate who had taught modern languages at Ball High School in Galveston since 1892 (and who is sometimes known as the father of high school football in Texas[2]), James didn't mince words. He went on for page after disparaging page about Galveston and Houston:

The people of Galveston are sadly in need of someone to lead them to a higher ideal of art … and are quite ready to accept any one who may wish to immolate himself upon their altar. If there is a person in the place who can tell a dollar chromo from a real water-color, he has so hidden his light under a bushel that the rays are all smothered. … We do all down here, reckon as how we don't need no longhaired Yankee female to come and teach us nothing about pictchers [sic]. … There are some nice people here, of course, … but they are people entirely without taste in house decoration or adornment. Furniture, curtains, carpets, pictures, are all inharmonious and vulgar. … The spirit of '61 is not dead – not here. A northerner is a 'Yankee' of course, no matter from where in the north he comes, and a 'Yankee' is in the common expression 'one damn fool.' … Now you may have received an idea that a mud-hole called Houston, is better – Don't you believe it … Reform is needed. A leader is wanted. Do you want the job? I hope not. Haven't you had enough forlorn hopes already? This would be the forlornest of the forlorn. … And the climate [is] too enervating. … I have always sworn by you as the one of the family having sense and reason. Don't destroy that faith by a nearer approach to the Southern Cross – for it is a cross, truly. … With interest in your welfare and sincere affection/Your brother/James Caffrey Richardson[3]

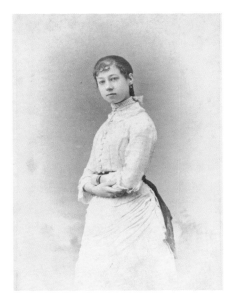 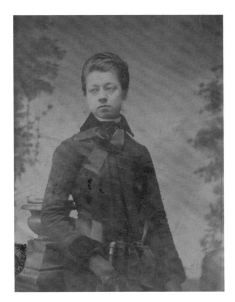 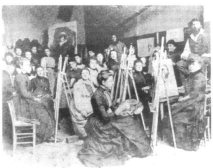

Emma Richardson ca. early 1870's (l), in New York ca. 1880 (c) and the class for women at Academie Julian, 1889 (individuals not identified, but the central figure in the foreground holding the palette appears to be Emma) (r)

Houston, and in fact all of Texas, can be grateful that Cherry did not take her brother's advice. Through her work as a teacher, lecturer, civic organizer and professional artist, she helped shape the art culture of Houston and the state. When she arrived in 1896, Houston was a small town of fewer than 30,000 people; it still fell far short of a million when she died in 1954. She brought with her a "Vision Splendid"[4] – a vision to make art, to share art and to continually move forward in art – to be "modern." Throughout her career, she was a conduit, bringing current ideas from the greater art world to the city. She was literally and quite consciously Houston's first modern artist.

Cherry worked virtually alone at first. Later, she inspired a core of forward-looking artists in the city decades earlier than is generally recognized, artists who were her students and, in turn, their students. As one commentator said, "all that Mrs. Cherry does comes back to us in one way or another. When she is not creating she is imparting."[5] Together they laid the foundation upon which the "mud-hole called Houston" would build the vibrant art culture we know today. But it all started with Cherry herself.

Art Students League/Impressionism

By the time she arrived in Houston in her mid-30s, Cherry had already established an impressive career as a professional artist – especially impressive in a time when the idea of a "professional" woman still raised eyebrows in some quarters. After early training from her father, Perkins Richardson, and in Chicago, she studied at the Art Students League in New York City from 1879 to 1885. She was elected a member of the League in 1883 and served on the Board of Control in 1885 – the only year the accounts "came out even" she later said.[6]

At the Art Students League she studied under William Merritt Chase, Walter Shirlaw, Kenyon Cox and others. As a young artist in New York and with such established teachers, Emma Richardson, not yet married, was exposed to the most advanced art known in the country. At the time Impressionism was the *modern* art just making its way to America.

Since Emma had already rejoined her family in Kansas City by May 1886, she may not have been in New York for the first Impressionist exhibition in the city, Durand-Ruel's "Impressionists of Paris," including almost 300 paintings, which opened in the galleries of the American Art Association on April 10, 1886. But she *was* still in New York at the time of the "Pedestal Fund Exhibition" in December 1883, organized by Chase and J. Alden Weir to raise money to build a base for the Statue of Liberty. This earlier exhibition included the first four Impressionist works exhibited publicly in New York: three paintings by Edouard Manet and one by Edgar Degas. Emma undoubtedly attended that show and saw those paintings.

She may also have seen other Impressionist works in private collections before she left New York. She would certainly have read about Impressionism in the art press and heard about it from other artists who had seen it first-hand in France – or even Boston, which embraced the new French paintings earlier than New York. But her own opportunity to see and learn this new art at its origin in Paris still lay some time in the future. First she rejoined her family in a new home in Kansas City after half a dozen years in New York.

Her time in Kansas City was not wasted. She set up a studio, took on students, and helped found The Sketch Club, the earliest art organization in the city.[7] She also agreed to marry her ardent suitor of many years, Dillin Brook Cherry, apparently with an understanding that marriage would not end her art career – or her plans to take up the life of an artist-student in Paris. After two years working and teaching in Kansas City, and only a few weeks after her marriage to Dillin, Emma – now Mrs. Cherry, as she would be called by almost all for the rest of her life – closed up her studio in October 1887.[8] By December she departed for an almost two-year stay in Europe, leaving her new and accepting, though at times uneasy, husband at home. [9]

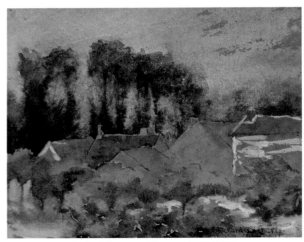

Rainy Afternoon, Giverny , 1888/1889

Normandy Fields, 1888/89

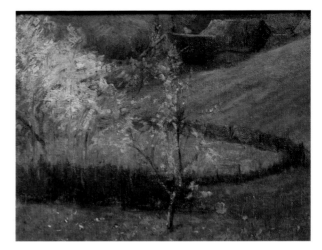

France—1890, 1888/89

Paris!

The Paris she found was a city recently transformed from medieval to modern by Baron Georges-Eugene Haussmann at the command of Emperor Napoleon III. Though visitors today may see Paris as a mellow survivor from the past, when Emma arrived in early 1888 it embodied modernity as did no other city in the world. Day by day she saw the Eiffel Tower, under construction for the Exposition Universelle of 1889, rising higher above the city.[10] Always an enthusiastic shopper (her later letters are full of her shopping adventures when she traveled), she likely ventured into the department stores that were reshaping the lives of middle class women like her. She had the chance to try food and drink wine she could never have tasted before. An eager young artist with a keen eye, she undoubtedly delighted in finding herself surrounded by an abundance of the most modern art by the most avant-garde artists at work in the art capital of the world.

Like thousands of other young artists, she had come to Paris to absorb that modernity. Paris appealed particularly to young women artists, whose opportunities for training and exhibition were often restricted at home. Even though the Ecoles Des Beaux Arts, the preeminent state-sponsored school of art in Paris, did not admit women until 1897, other schools did admit them, though often in classes separate from male artists. Cherry chose to study at Academie Julian, already established as the most popular Paris school for young American women seeking serious art instruction.

Emma came even closer than most to the source of Impressionist modernism. Her companion in France, Mary Hoyt Sellar, a childhood friend from Aurora, IL, married the young English artist Dawson Dawson-Watson. It must have been a whirlwind romance, since the bride had only reached France in January 1888 and the couple married in May.

Dawson-Watson was one of the founding members of the embryonic art colony at Giverny, the town where Claude Monet had lived since 1883. During the first five years of their marriage Sellar and Dawson-Watson spent most of their time in Giverny. Dated drawings in Emma's sketchbook suggest that she may have visited them there as early as June 1888; she definitely did so in October 1888 and April 1889.[11]

It is unlikely that either Dawson-Watson or Cherry had any contact with Monet. He seldom taught and did not socialize with the bothersome (in his view) foreign artists who were beginning to come to Giverny. Dawson-Watson later claimed that he did not even know Monet was there when he first arrived.[12] Nevertheless, the two embraced Impressionism in the works they made at Giverny, sometimes even painting the same scene side-by-side.[13] Her *Rainy Afternoon, Giverny*, *Normandy Fields* and *France – 1890* (actually painted in 1888/89) are among the earliest paintings done at Giverny by an American artist, and are perhaps *the* earliest done there by a woman of any nationality.[14] As she prepared to return home in late 1889, Cherry was already in the vanguard of American Impressionism.

Denver/Houston/First Impressionist Exhibition in Texas

In December 1889, Cherry joined her husband in Denver, where he had moved during her time in Paris. She brought with her an experience in modernity and Impressionism that set her apart among artists in her new home, and that would make her unique when she moved on to Houston in the mid-1890's. In both cities she knew that she had something new and important to share. In 1894 she borrowed paintings from her friend Dawson-Watson – recently moved from Giverny to Hartford, CT – to exhibit as the first Impressionist paintings in Denver.[15] Not long after she got to Houston she found her opportunity to bring art modernity to the Texas Gulf Coast when she was appointed superintendent of the Art Exhibition for the Texas Coast Fair to be held in Dickinson in November 1896.

It is plausible to think of this as the first exhibition in Texas that was curated in a modern sense. Rather than show only works close at hand – the usual practice for local exhibitions at the time – Emma brought the best examples she could borrow from around the country to illustrate the vision she had in mind. It was also the first "Impressionist" exhibition mounted in the state.[16] Cherry patterned the exhibition on those she had seen at the 1889 Exposition in Paris and the World's Columbian Exposition in Chicago in 1893.[17] Once back in Denver after the Chicago visit, she had been so intrigued by the concept of Fair Art that she had given a series of lectures on the topic.[18]

As was to be expected in local exhibitions, Cherry included local artists in the Coast Fair show. Frank Reaugh, Janet Downie, Edward Eisenlohr, Eloise Polk McGill and a number of other Texas artists sent work. But her intention was to show Houston and the Gulf Coast what was happening in art, not just at home, but around the country and in Europe. To achieve her goal she used her extensive network of contacts to bring the best works she could borrow from Denver, Chicago, New York, Boston and elsewhere – all for an exhibition that lasted only five days.

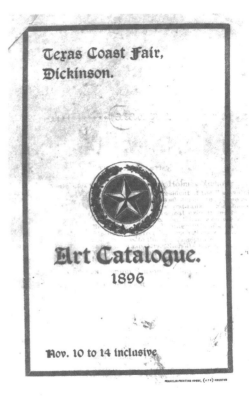

Cover of the Texas Coast Fair art catalog, 1896

Hers was a staggering ambition for that time and place, recognized even then as an amazing achievement. In the words of Prof. F.W. Mally, secretary of the fair: "She [Cherry] is a hustler, as you will understand when I tell you that I have boxes of paintings from the best artists in New York, Kansas City and Denver ... The shipment from New York was much larger than I expected, and just arrived via the Mallory steamer to Galveston a few days ago."[19]

As was popular at the time, she included posters and illustration art, in addition to paintings, watercolors and drawings. Posters by Louis Rhead, J.C. Leyendecker, Will Bradley and her Art Students League teacher, Kenyon Cox, were all represented in the exhibition. She even included china painting and sculpture in plaster. But her primary goal was to expose those in her new home to the newest of the new art – at least for her local audience – Impressionism. She explained her intentions in the *Galveston Daily News* of November 8, 1896:

In the coast fair art exhibit there will be a new feature this year, inasmuch as we will have for exhibition a few examples of the impressionist school of painting. This school ... was composed of artists who resented many of the old ideas of the rendering of nature – the dark, dingy coloring – the tight, hard drawing, the lack of vibrating atmosphere and the belabored finish ... [The new artists] felt, and do still feel, that there is beauty in brilliant sunlight ...; that color is as attractive when pure as when 'toned down.' That the air moves and does not appear hard and unrelenting. The freshness of their subjects is often due to their seizure of transient effects in nature, things that must be seized and grasped quickly – and waited for again and again – to be studied. ... After a while one leaves behind one's old preconceived idea of how nature has looked – on canvas – and sees that, after all, the impressionists can not key nature to a higher or a purer key than she is found to possess in herself – out of door – and we begin to see we were the color blind people, and these painters have helped us to take off our toned tourists' glasses so that we may be out under the influence of nature's own light.[20]

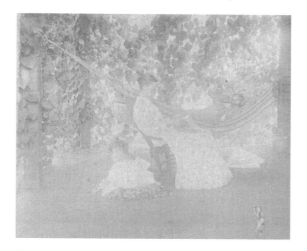 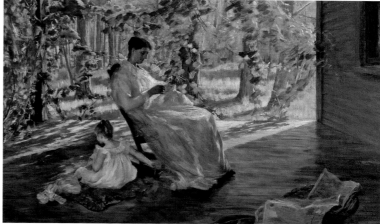

Photograph, probably taken by Ruth Richardson, showing Perkins Richardson, Frances Richardson and Dorothy Cherry on the gallery of the family home, The Pines, south of Houston, ca1896 (l); *On the Gallery*, 1894 (r)

As she had for the Denver show two years earlier, she borrowed works from Dawson-Watson. This time she also borrowed from his fellow Giverny pioneer, Thomas Meteyard. Frank Reaugh, who like Cherry had studied at Academie Julian (they were even there at the same time, though there is no indication that they knew each

other then) qualified as a member of the "Impressionist school" as, of course, did Mrs. Cherry herself. Her *On the Gallery*, showing her mother and daughter on the gallery of the family home south of Houston – not far from the fairgrounds where it was exhibited, in fact – was a superb example of Impressionist painting, reminiscent of Cassatt. It is made even more interesting today because of her use of a photograph as her source – a technique used by many of the most advanced French artists of the day.

The exhibition was an amazing achievement, as noted by a reviewer at the time, "The art exhibit at Dickenson … is generally conceded to have been the best thing of the sort ever held in this part of the country…"[21] That the reviewer was Cherry's sister Ruth Richardson did not diminish the truth of the observation.

Italy

Since Cherry herself was almost the only conduit for the flow of modern ideas of art to Houston during her early years in the city, it is not surprising that most of her own advances happened elsewhere. She traveled as often as she could, almost always with an art purpose in mind: to encourage art appreciation, contribute to founding arts organizations, see art exhibitions, visit art friends, or study to advance her own art.

After a decade in which she was more involved in the civic and teaching aspects of art – including a major role in founding the Houston Public School Art League to bring art to schools, and in teaching her own students through her own school – by 1910 she was ready to focus for a period squarely on her own art.

It had been ten years since her last trip to Europe. That trip had been as a tourist accompanying her brother and sister-in-law on a visit to the Paris Exposition Universelle of 1900, followed by a grand tour through France and Switzerland. As always, she sketched as she went but she had no time for study.

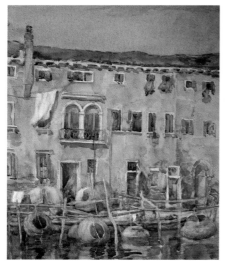 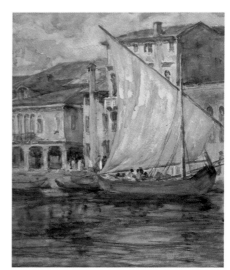

Fishermen's Homes – Giudecca (l); *San Clemente* – Rome (c); and *Yellow Sail*—Venice (r), all 1910

Improved family finances (Dillin was having success in oilfield wildcatting and real estate development) meant that there was enough money for another European adventure, this time alone and specifically for art. She decided on a year in Italy, intending to concentrate on watercolors, as were many American artists of the period. Maurice Prendergast, for instance, would produce many of his finest watercolors during his second trip to Italy the next year. Though she was already an accomplished watercolorist, having studied with Rhoda Holms Nichols in New York in the 1890's, she reached even greater heights as she made her way from Sicily, to Capri and Naples, on to Rome (where she studied with the Spanish artist Vicente Poveda y Juan), through the Italian hill towns and Florence, ending in Venice for several months of work with Vettore Zanetti-Zilla. The chance to spend so long focused squarely on her own art brought her back to life as an artist. Along the way she produced some of her most beautiful paintings. Writing to her husband from Sicily, she said:

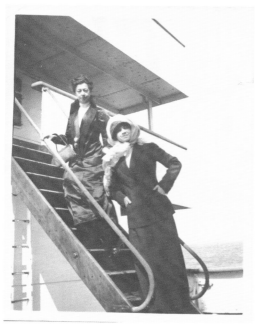

Emma Richardson Cherry and Dorothy Cherry onboard ship, 1911/12.

Thought at first my spring was dried up. I had such a time getting into working shape – so long doing nothing much makes one so rusty. When I come home I must have the studio fixed up & really do something regularly – or give it up entirely – as I can't hold my grasp if I let go so long again.[22]

Cherry had planned to spend a year in Italy. But when the news reached her in September that her sister Ruth was dangerously ill, she decided to return home early.

Ruth's death in February, 1911 was a blow from which Emma never fully recovered. Ruth Richardson Mayberry (1874-1911) was the youngest of the Richardson siblings. She was, according to surviving accounts, an attractive and accomplished woman. A talented newspaper woman, she was elected to membership in the Texas Women's Press Association in 1896.[23] In the early 1890s she, along with their mother Frances, had cared for Dorothy while Emma stayed in Denver. Ruth left behind a grieving husband and a young daughter, also named Frances, who was taken into the Cherry household almost as a younger sister to Dorothy, while her father pursued business ventures in Mexico. The loss of Ruth would linger in Emma's mind and in her letters for the rest of her life.

"Finishing" Dorothy and a Grand Tour

At the same time, Emma had a daughter of her own to think of. In the spring of 1911 Dorothy graduated from the Mulholland School for Girls in San Antonio. Since their financial situation permitted, the family – no doubt strongly influenced by Emma, with Dillin's acquiescence, as was often the case – decided to give her a year of "finishing" in Europe. In September 1911, Mrs. Cherry, Dorothy, and her San Antonio schoolmate Ruth Lipscomb, sailed for Europe (on the same ship out of New York with Gertrude Stein's brother Michael and family,

as it happened[24]). Until March 1912 they were in Brussels, where Dorothy and Ruth attended Mlle. Delstanche's Boarding School for Young Ladies and Emma painted. Then from April to November 1912 they made a grand tour of The Low Countries, Germany, Switzerland, Italy and France, including several weeks in Emma's beloved Paris.

Houston in the Teens/Advent of Modernism

The second decade of the century saw the serious art community of Houston, previously comprised of Mrs. Cherry and a very few others, mostly women, including Penelope Lingan and Hattie Virginia Palmer, greatly augmented with the arrival of two men. John Clark Tidden, charming, handsome, and a promising young artist, arrived in 1914. He was joined a couple of years later by James Chillman, Jr., himself an accomplished watercolorist who would subsequently serve as the founding Director of The Museum of Fine Arts, Houston. Tidden and Chillman came to teach watercolor and drawing in the Architecture Department at the newly opened Rice Institute. Both were Philadelphia men, an attribute not always viewed as a plus by Cherry, but their art credentials were unquestionably good.[25]

Tidden had studied with Hugh Breckenridge at the Pennsylvania Academy of the Fine Arts, and was one of two candidates recommended by Breckenridge to William Ward Watkin to teach at the Institute – the other was modernist painter Arthur B. Carles.[26]

Over the next decade a number of Tidden's more promising Rice students left, even before graduating, for art study in Philadelphia. At the time, and for the next fifty years, art instruction at Rice was simply an adjunct to architecture – those who were seriously interested in pursuing art had to go elsewhere. So Philadelphia and the Pennsylvania Academy of the Fine Arts were then very much in the minds of Houston artists.

Whether as a result of her contact with Tidden or simply because she determined that the School offered the instruction she wanted at the time, in 1919 Mrs. Cherry enrolled in the summer program of the Pennsylvania Academy of the Fine Arts at Chester Springs. As she took up her brushes in Chester Springs, Cherry began a decade-long immersion in color and modernism that had a transforming effect on her own work and on the art culture of Houston.

Always interested in the new when it came to art, Mrs. Cherry had become increasingly intrigued by modernism since her first encounter with Cubism in 1912. She did not attend the most important modernist event of the time in America – the 1913 Amory Show, as it is now known, which opened in New York City in February and toured to Chicago and Boston. At the time she had only recently returned home to Houston after a year and a half in Europe and perhaps felt the need to stay put for a while. Even so, she had already had a look at the "modernism" that made the Armory Show such a sensation. On October 13, 1912, she and Dorothy visited the Autumn Salon in Paris, one of the earliest major exhibitions anywhere to include a substantial representation of Cubist paintings.[27] What she saw that day remained so vivid in her artist's eye that in 1920, as she related a

meeting in Gloucester with Marsden Hartley in a letter to Dorothy, she described him as a painter of "…very modern pictures – like some of those things we saw at the autumn Salon in Paris."[28] Her passion for modernism sparked that day in 1912 – and her determination to bring that modernism to Houston – flamed for the next twenty years.

For most American artists, World War I precluded study in Paris, the center of modernism. But the ideas were in the air of the American art world, due both to the furor surrounding the 1913 Armory Show, and to the presence in New York of some of the leading French modernists (Duchamp, Picabia, Gleizes) who had crossed the Atlantic in part to escape the hostilities of war. A few American artists – Marsden Hartley, Max Weber, John Marin and others – some recently back from Europe, were also beginning to create an American modernism. So the currents of modernism were flowing in the country, but finding entrée into that nascent American modernism from a place then as remote from the centers of art in the United States as Houston was not easy. For Mrs. Cherry a summer at Chester Springs was a good first step.

Color and Neo-Impressionism/Chester Springs and Gloucester

Flying Prisms, ca1920 (l); *Dull Day on the Cove*, 1920 (r)

Henry McCarter, with whom she studied at Chester Springs, was a long-time instructor at the Pennsylvania Academy of the Fine Arts with a particular interest in color. One critic noted that his "unusual color combinations— lemon yellows, soft blues, and pinks – take on an elegiac quality." [29] Emma embraced the opportunity to study color in a modernist context. Recounting Cherry's comments during a guided tour of her work in January 1920 – a few months after her time at Chester Springs – a reporter for the *Houston Post* wrote "…these modernists teach that painting is scientific from its very elements, and taking the prism as an instrument they study what they call the sequence of color and the relation of color to the landscape and nature and especially under out of door conditions."[30] Cherry took the prism literally in creating *Flying Prisms*, one of her earliest modernist works – and also a foray into abstraction at a level she seldom approached.

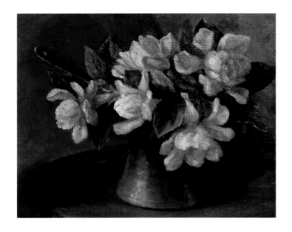

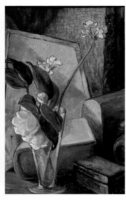

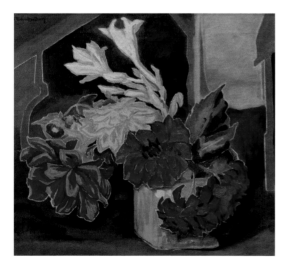

Sequence of flower still lifes demonstrating Cherry's move toward modernist technique: *Cape Jasmine In a Copper Cup* ca-early, 1900s (t); *Bouquet Of Jasmine* ca-early, 1900s (cl); *Narcisus* [sic] *In Studio,* ca1920s(cr); *Decoration,* ca1920s (b).

While at Chester Springs she also began to explore the Neo-Impressionism espoused by Hugh Breckenridge. She continued that exploration the following summer when she attended Breckenridge's new school in East Gloucester, MA.

Hartley & Full Modernism

The weeks spent in East Gloucester in August and September of 1920 saw a seismic shift toward modernism both in her thinking about art and in her work. Throughout her career, she often made such rapid shifts once exposed to the "new" in art. She studied the new thing she had encountered, experimented with it, adopted the aspects that seemed right for her own work and teaching, and then moved on. But seldom was the shift as sharply delineated or well documented as the "red letter day in a red letter summer" – Sunday, September 26, 1920 – which she described in a letter to Dorothy from East Gloucester written a few days later. That was the day she painted with Marsden Hartley.

She described Hartley to Dorothy as "a man who writes modern poetry" and, as previously noted, a man who "also paints very modern pictures – like some of those things we saw at the autumn Salon in Paris [in 1912]."

She found Breckenridge an encouraging and "liberal" teacher, but she had come to feel that she …:

…wanted more modern help. So the other day I asked Mr. Hartley if he would come & look at my summer's work & see if he thought I had any inclinations that suggested I could break loose and really do modern stuff. (He had already told Mr. Pancoast that Miss Dercum & myself were the only ones in Breck's class that showed thought in our work)

Well he came & was quite interested – said I had plenty of things good enough for my Baltimore show – and to go on with it by all means. Then I showed him my modern flower one & he was very enthusiastic – said "well, if you can draw like that you can go any length you wish." You can imagine I was pretty happy.

I had on the table a thing I had just brought in & we talked about it & I asked him if he would let me pay him for a few crits & show me some things I did not know how to go at to express – said he would be glad to and therewith started in on my wet paint & I can tell you its far & away a mighty interesting thing he is doing, with my puddling around in it, pretending to help. I am so happy & enthusiastic over this chance it seems worth the whole summer. I wish I had had him all this month of Sept. but it never dawned upon me he would be willing and I was timid about speaking up. This has been a red letter day in a red letter summer.

I am going now to Mr. Hartley's studio to see his last work – as he is packing this afternoon to go to N.Y. He says when I go there he will let me know his address & will himself take me around to see the modern things. That will be fine because I will meet the dealers & I hope some of the artists.[31]

Cherry also met Stuart Davis that year, either in Gloucester – they were both there for part of September – or in New York, perhaps on the promised Hartley-led tour. There is no evidence that she painted with him, as she had with Hartley, but Davis thought highly enough of her that he sent a personal invitation to his show at the Whitney Studio Club in New York City, April/May 1921. [32]

Société Anonyme Inc.

Cherry's encounters with Hartley, Davis and other artists in Gloucester were invaluable in her growth as a modernist, but the impact of joining the avant-garde *Société Anonyme Inc*, probably at the suggestion of Hartley who was himself an active member, may have been even greater. Founded in New York in 1920 by Katherine Dreier, Marcel Duchamp and Man Ray, *Société Anonyme Inc* intended to cultivate among Americans an appreciation of the ultra-modern ideas in art first brought to America from Europe in the early part of the century. Styling itself as a Museum of Modern Art (though with no connection to MOMA, founded some years later by a different group), *Société Anonyme Inc*, as structured by Dreier, functioned as an international web of art connections, stretching from New York to the art capitals of Europe and to the other major cities of America in the northeast and Midwest. Through Cherry, who joined in October 1920 (and who was the only Texas member among the fewer than one hundred worldwide), one strand of the web stretched all the way to Houston.[33]

There is no indication that Cherry had artistic interaction with Duchamp or Man Ray – even at the level of her interaction with Hartley. But simply as a member of *Société Anonyme* she encountered their ideas. She received the publications sent to all members. She saw their work and heard their ideas as she attended *Société Anonyme* exhibitions and lectures when in New York. Hartley even sent a personal note inviting her to his lecture on modern painting in December 1920:

Dear Mrs. Cherry, Sorry you can't be here to listen to my paper on modern painting. When shall you be in New York? I hope before long. … Do let me know when you are coming. Sincerely, Marsden Hartley[34]

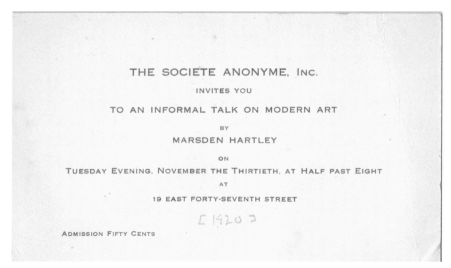

Note from Marsden Hartley to Emma Richardson Cherry inviting her to his lecture at Société Anonyme Inc, December 1920

Throughout the early 1920s, Cherry maintained a correspondence with Dreier. The two found common ground as members of the Art Students League and former students of Walter Shirlaw. Dreier saw in Cherry a means of extending the reach of *Société Anonyme* to a new region, even working through Cherry to donate a painting by her late sister, Dorothea Dreier, to the Museum of Fine Arts, Houston. Cherry adopted Dreier as a sort of unofficial mentor in modernism, though she realized that her work was not quite modern enough for Dreier's taste and purpose.

In a letter to Cherry from October 1920, Dreier said:

Do send us a catalogue of your work, and maybe at the close of it [Cherry's Baltimore show of October 1920] send us two of your modern paintings, which I would like to see, to see if we can enter it [sic] into any of our this years' exhibitions. It would interest me especially to see the picture which you and Mr. Hartley worked on together. I am so glad to get news of him, as I have many messages from his Berlin friends, who I saw this summer. Won't you send me his address.[sic][35]

Writing to Dreier from Houston in April 1924, Cherry said:

I have a small, very small head at the Independents – "Color Sequence" which I think is quite a step for me. If you go in again would you look at it? I have the "Reflected in a Mirror" – which you saw in my studio in New York – not advanced enough to interest you, of course."[36]

The "studio in New York" that Cherry mentioned was at the Metropolitan Art School in the Sherwood Studios building where she filled in for the Director, Michel Jacobs, during the summer of 1923. While there she had her only one-woman New York show, reviewed favorably in the New York Times, even though it hung for only one day:

She uses traditional subject matter that is realistic landscape and portraiture, and applied the modern or rather ancient laws of scientific color and mathematical structure… Not only is Mrs. Richardson [Cherry] a painter of ability, but also an inspiring teacher. She makes her pupils realize the importance of the science of their art…[37]

She shared the studio that summer with her Houston student, the future avant-garde filmmaker, Mary Ellen Bute, who later wrote:

It all started while I was a pupil of the remarkable painter and teacher in Houston, Emma Richardson Cherry. Mrs. Cherry then arranged for me to study at the Pennsylvania Academy of Fine Arts under Henry McCarter. At that time everyone was concerned with Cubism, Impressionism and other styles that derive from the desire to obtain the illusion of movement on canvas.[38]

Though New York was her base for much of the Spring and Summer of 1923, Cherry also appears to have visited Philadelphia. While there she saw, at the Pennsylvania Academy of the Fine Arts, the first public showing of the collection being built by Dr. Albert Barnes. She noted the event two years later in a letter written from Paris recounting the impact of a visit to an exhibition of paintings by Modigliani: "I had seen some in Philadelphia in Dr. Barnes marvelous collection – so was somewhat prepared."[39]

The Brittany works/ Burchfield-ian colors and forms

By 1925, with the 20s at full roar; the economy booming (or at least prospering in the case of Mr. Cherry's oil and real estate ventures); the European currency exchange rates massively in favor of the US dollar; and thirteen years after her last visit to the Paris she loved, Mrs. Cherry was eager to return. Especially so since Paris was unquestionably the center of the artistic modernism she so eagerly wanted to assimilate, even in her mid-60s.

In June she set sail for France with the intention of staying until December 1925. Little by little her stay extended to September 1926. But it was summer when she arrived in France, and Paris in summer was hot and semi-deserted by those who could afford to leave. She and her companion, Clemens Tanquary Robinson (called "Clemmie Tan" by Cherry, whom she called "Cerise") decided to start their stay in Brittany. Clemmie was a New York friend in her twenties who was herself an artist. Rather than Pont-Aven, perhaps the most famous art colony of Brittany, they chose the small sea-salt producing town of Guerande as their base. They had read about it in a guidebook and been charmed by the description. But they did visit and paint in Pont-Aven, and other towns along the south coast as well, during their two-month stay in Brittany.

From the letters Mrs. Cherry wrote home, and the very frequent ones Clemmie Tan wrote to her new husband, who was in Russia for a year of research, it is clear that they both worked hard, sketching and painting diligently. Clemmie Tan looked to the much older and more experienced Cerise for guidance in her career path, as well as for companionship and encouragement in her art. On July 8 she wrote, "Cherry is a really remarkable teacher."

Thanks to Clemmie's admiration and her longing to share her days with her new husband, many details of Mrs. Cherry's summer in Brittany are preserved that would otherwise have been lost.[40] On August 7 Clemmie wrote, "Cherry has torn loose and made her first modernistic picture, since our arrival – she's as pleased as punch." It is not clear which of Cherry's Brittany paintings Clemmie had in mind. But the impact of the Brittany experience *is* clear in a number of the paintings Cherry produced there, many exuding an almost Burchfield-like alternate world-ness – for example *Padre's Walk* and the spare, enigmatic, haunting *Shadow Patterns* – unlike anything she had painted before.

The Bridge to Cubism

At the end of their summer in Brittany, Clemmie Tan went straight to Paris, leaving Cerise to make a slower progress there by way of the Loire Valley, for a look at the chateaus, and then on to Chartres. In Chartres she did a small watercolor of the "humped" bridge over the River Eure – a painting of a *literal* bridge which, by combining her long-held interest in color with an exploration of geometric shapes new to her work, made an apt *metaphorical* bridge to the Cubism she was going to Paris to learn.

Paris! For Cherry the word seemed to have almost magical powers. She loved the art, the music, the food, the fashion – she loved living the semi-bohemian life of a serious, professional American woman artist of a certain age and a certain class on her own in Paris. In fact she loved everything about the city:

One finds so much of interest that the days are full. Things to see, things to hear, things to think about, and things to do, all crowd the hours beyond capacity. A human being needs strength, brains, energy and application, and of course, some money, to seize even the crumbs that fall from the Parisian table. I thought I appreciated Paris on the other four visits, but never has it seemed so interesting and full of charm as this time. I suppose one should appreciate more as the years roll on. I only wish I might always be on the globe to see the changes and join in the surging throng. It's all so worthwhile.[41]

But she had come to Paris with one overriding purpose – to advance her exploration of modernism:

Shadow Patterns, 1925

Padre's Walk, 1925

For I want a month at least here to have some work in a studio of a man L'Hote, who gives one Dynamic Symetry [sic] applied to the figure. I've seen the work of one of his students and talked with her. He is a modernist, of course, else I would not want him. I am ... going once more to the Exposition, to see my favorites, and once more to the Autumn Salon – (all modernists).[42]

I have written Ola [McNeill Davidson] how much I want her to come – and to only bring a suit case or cases -- & only two warm dresses & spats, if she wears low shoes – for it rains almost every day – and of course an umbrella. I asked her to read you the letter as there is a lot in it about L'Hote's studio and his ideas. It's just what I am trying to work out & did to some extent in Caroline's picture – so I am doubly pleased.[43]

I'm pretending to be a young art student again, joining a private class in Andre L'Hote's studio. He is considered the leading exponent of modified cubism in Paris. He is a very keen appreciative critic, giving endless time to his followers.

L'Hote takes life lightly but art most seriously. The studio is a jolly place during rest times, but a beehive during the poses. It's fine to assimilate a growing idea, especially when so well founded upon the great art of the 'Old Masters' as L'Hote's is. 'Organization' is his hobby, and he is a very constructive worker. If all 'modernists,' so-called, had his hold upon the underlying principles of composition, it would be a resurrection from incoherent and unassembled painting, sculpture and applied art.[44]

In Paris with a congenial companion, visiting exhibitions of the latest work by the most advanced artists (Modigliani, Vlaminck, Picasso, Braque), able to concentrate on her own work with only the pleasant distractions of an active life in an exciting city, Cherry found an excitement and an exhilaration that had waned for her in Houston:

Sorry not to be there for the entertainments of and for the Southern [States Art League] – but guess I won't miss much – compared to what I am absorbing over here – I'm a back number in Houston anyway – But I am enjoying myself in my work & that's the most

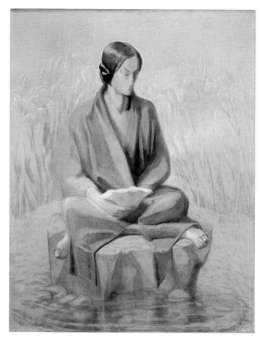

Precious Bowl (i.e "Caroline's Picture"), 1923

Bridge at Chartres, 1925

important part. Fashions in art come & go – and the Bruce Crane & Francis Murphy &c – won't always last – even in Houston. I'm not bitter but growing indifferent to my environment – for it's the only way I can be happy – Ruth [Richardson Maberry, her sister] used to tell me that – but I was ambitious to make a __name__ – Now I don't care.[45]

After a tour through Spain and North Africa and several winter weeks in Majorca, she was back in Paris for another long stay:

After all it seems good to be back again in Paris where I feel more at home than in New York – I walked all the way to the Grand Palais – to see the Retrospective Independents – 1890 to 1926. And I went through all the by streets and looked into all the book shop and antique shop windows … and decided Paris is some interesting ville – for about the hundredth time![46]

But she knew that her Paris life could not go on forever. She took a summer trip to Ireland and England, visiting friends, showing her work in Dublin and London, and sketching and painting everywhere she went. And then, eagerly as well as a little sadly, she made her plans to return to family and home in Houston.

She had been away almost fifteen months by the time she disembarked in the fall of 1926. Her work had been selected for the Salon des Beaux Arts in Paris and exhibited in the winter 1926 Exhibition of Modern Art in Dublin. She had visited with old friends in Paris and London and made new contacts all along the way. But for her, and for the art community of Houston in the coming years, the most important memento she brought with her when arrived in early October was her deepened understanding of and enthusiasm for modernism. The most precious souvenirs packed in her trunks were dozens of paintings, drawings and sketches – including the first Cubist paintings done by a Houston artist – in which she had tried to capture the new things she had learned.

Feeling Forgotten

At sixty seven, though she would live and work for another twenty eight years, Cherry sensed that the trip would be her last for extended, unfettered study, and she was right. She did travel twice more to Europe, in 1928 and 1930, with stops in Paris both times, but the main goal of those trips was to seek treatment for her failing hearing at the Clinique Reymond in Fribourg, Switzerland.

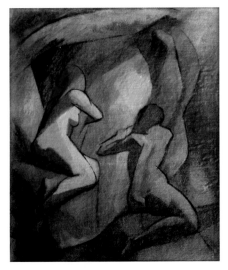

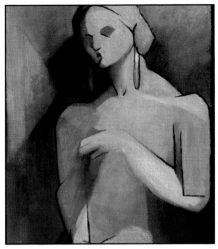

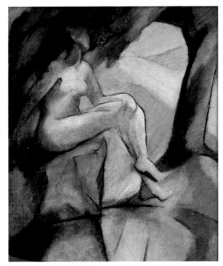

Arrangement (t); *Study in Compositional Spaces* (c); *Pan's Pool* (b), all 1925

She also made further trips to New York, Chicago (in 1933 to see the Century of Progress International Exposition, her sixth World's Fair), and other cities around the country. But more and more her travel was limited by age and its attendant infirmities, particularly the failing health of her husband; by lack of money as the Depression dug in and Mr. Cherry's always dicey business ventures foundered; and perhaps even by a faltering interest in being away from her only grandson and from her daughter, upon whom she came to depend more and more as she entered advanced old age.

But her interest in taking new turns in her art, and in teaching what she found around each turn, did not falter. The drive to teach grew both from her love of "imparting," as the newspaper reporter had said so many years before, and from necessity: she needed the money. Even into the 1940s, well past eighty, she was looking for new, *paying* students.

The drive to explore new things through her art was the habit of a lifetime. In the late 20s she changed her palette from exuberant boldness to the muted quiet of her bookplate-inspired Ideson murals, funded through the Public Works of Art Project (PWAP) in 1934.

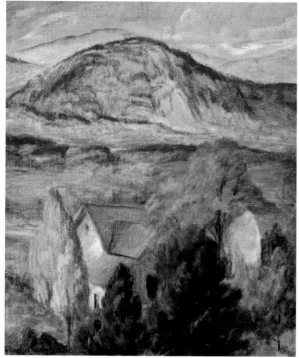

Across the Valley, 1929

As she had throughout her career, she continued to paint portraits whenever she could get commissions, though the demands of portrait painting grated against her instincts as an artist:

I would like to paint portraits if I could paint my sitters as I see them. … No one else sees quite as clearly as the artist. But sitters don't like that clarity in their portraits. They want to be painted as they think they should look. That is not true art.[47]

Even in the late 1930s, when the income from her art was vitally important to her and her family, she could not let the market dictate entirely when she could find a way, even if a little devious, to keep the art fresh while remaining the thorough professional she had always been:

I learned to do academic, pretty things when I was young…As I became more mature, I wanted to make my work more different. I wanted to inject modernism into it. I studied hard to acquire that modernism. But many people do not like it. And I was painting canvases to sell.

So I worked out a plan. My canvases are built carefully, almost on the cubistic plan – but I shield the underlying structure with detail, sheer prettiness. It gives me pleasure, and not many are the wiser.[48]

Students and Grandstudents

As she grew older, Cherry felt more and more neglected or, even worse, forgotten, by the Houston to which she had given so much. She had written from Europe in 1925, "I'm a <u>back number</u> in Houston". Writing to Dorothy about having her painting, *Valldemosa*, selected for the Paris Salon in 1926 she said, "It will make me good at

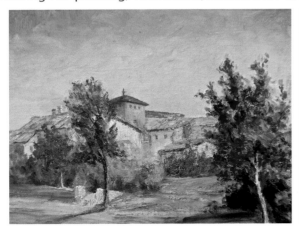

Red Oaks House Randolph Field, ca1937, with diagram by the author showing Cherry's use of Cubist technique as a foundation for the painting

the Museum and with a few who hesitate about me."[49] In 1934, as she neared completion of her Library murals, Cherry wrote to Dorothy that two colleagues thought, "the murals will make me famous in Houston. But what good will *that* do! Might work if I was from N.Y. or Paree."[50]

Some at least had not forgotten her, chief among them her own students and their students. Many of them felt a real affection for her. But, even more important, they admired her art and appreciated the crucial role she had played in bringing advanced art ideas to Houston decade after decade. Replying to what must have been a gloomy letter from Mrs. Cherry in 1950, Ola McNeill Davidson, perhaps her most devoted student, and herself an influential teacher of some of the most innovative artists in Houston in the mid-20th Century, said:

… everything I have done for my group has come through my appreciation for what you have done for me. Always I ask myself, what would I have done had you not come my way to guide me to the loftier things of life. These boys [Davidson's group of avant-garde young artists] were very unhappy when they came to me – misfits socially and didn't realize <u>why</u>. Starved, yet didn't know where to turn for expression. Of course I understood their needs because of what you had done for me – and so like you I shared untiringly all I had; travel abroad, books, materials[,] my very soul so that I might be able to "open that door" you opened for me.

So please do not say "Cherry McNeill group! has an interesting past …" How can that be past? No Mrs. Cherry that thing we accomplished while active with them flows on and on – it is a chain with you the biggest link – without you and the showing of the way there would be no Robert [Preusser], Carden [Bailey], Gene [Charlton], Harley [Brubaker] and a number of others on their way to top in their field that you do not know. Teachers are born and it is not so much the teaching as the environment and encouragement.[51]

Cherry in her studio with students ca1930's (t) and
Ola McNeill Davidson painting (b) ca-late 1930's.

Glowing praise from a devoted student to an elderly teacher. But Davidson's assessment was, in fact, accurate. By the late 1930s the "Cherry McNeill Group" – including Frank Dolejska and Forrest Bess in addition to Charlton, Bailey, and Preusser among the boys and Maudee Carron and Nione Carlson as the clearly much less favored (in Davidson's eyes) girls – formed a small core of young artists eager to see, learn and paint the newest of the new in their art.

As she said in her letter, Davidson nurtured her group as Cherry had nurtured her. In 1937 she accompanied Charlton and Bailey on a trip through France and Italy (a first for all three) so that they could see in person the art they could only read about in Houston. Together in 1938 the group opened a short-lived gallery of "non-representational" art in Houston in which they all showed work – probably the first gallery anywhere in Texas devoted solely to abstract art.[52] In 1939 she took Preusser to Chicago to study at The Chicago School of Design. Afterwards she recounted to Cherry the bemused amazement of Laszlo Moholy-Nagy, founder of the school and formerly an instructor at the Bauhaus in Germany, that work such as Preusser's could come out of Texas.[53]

Their work garnered notice both in Texas and further afield. In 1936 Alexandre Hogue described Charlton and Bailey as "the most progressive artists in Houston today, and the least appreciated."[54] After World War II, Charlton had a Houston-New York back-and-forth career for several years (showing in New York with Mark Tobey, David Smith and Mark Rothko), before moving on to Rome in the late 50s. In 1966 a critic compared his work favorably to that of fellow Palazzo Pio studio holder Cy Twombly.[55] Charlton's last Houston show in 1961 included collages (several now in the Menil Collection) compared by a critic years later to the contemporaneous work of Robert Motherwell.[56]

After the War, Preusser and Dolejska helped found the Contemporary Arts Association, precursor of the present Contemporary Arts Museum, which aimed to bring to Houston the latest in art and design. In the mid-1950s Preusser began a teaching career at MIT that lasted the rest of his life. Charlton, Bess, Preusser and Carlson all showed more or less frequently in New York in the late 40s and early 50s.

A Legacy

In the 1950s Houston was a very different place from the "mud hole" in which Cherry had arrived in 1896. The city's economy was booming, and its population was burgeoning. The art scene exploded with the energy of young artists and the dedication (and money) of new patrons, such as the De Menils. As Cherry approached the end of her long career, even she had difficulty seeing her relevance, hence the encouraging letter from Davidson previously quoted.

Emma Richardson Cherry painting en plein air, ca early 1950s

As she grew older and less able to travel in search of the "new" in art, Cherry's influence began to fade. At ninety five, most of her contemporaries had died. The "Cherry McNeill Group" had matured and dispersed. Those new to the city hardly knew who she was. Even her advanced works, which had been cutting-edge in Houston when they were new, had come to look old fashioned. Her paintings, hundreds of which she retained at her death, were stacked in storage. The city had moved on and saw little reason to linger over an artist so clearly of the past.

But it is upon the foundation which Cherry laid down that the art culture of Houston – whether in the 1890s, the 1920s, the 1950s or today – has been built. Emma Richardson Cherry was Houston's first modern artist. For decades she was "the biggest link" between Houston and the newest ideas in art. Even now she remains the biggest link between contemporary Houston and its formative early art history. Houston is now a vibrant art center. Without Cherry and "the showing of the way," things would be very different.

ENDNOTES

Endnotes - Emma Richardson Cherry: A Life to Be Lived by Lorraine A. Stuart

1. Manuscript, *A Brief History of Art Progress in Houston as Part of the Art Development of American During the First Quarter of the Twentieth Century*, c August, 1926, Stella Hope Shurtleff. RG19 Houston Art League records, Box 3, folder 40. Museum of Fine Arts Houston, Archives.
2. At her death, she was believed to have been the Art Students League oldest surviving member. John and Deborah Powers, *Texas Painters, Sculptors and Graphic Artist: A Biographical Dictionary of Artists in Texas before 1942*, p 91.
3. A schoolteacher at the time, Roberta Lavender became a Latin professor and the Dean of Women at the University of Texas at Austin. *Manuscript*, 1917. RG19 Houston Art League records, scrapbook, p 64.
4. RG19 Houston Art League records, scrapbook, p 1.
5. Houston Daily Post, 7/16/1899, Image 14, http://chroniclingamerica.loc.gov/.
6. Meredith Evans, *A Pioneering Spirit: E. Richardson Cherry and the Development of the Arts in Denver, Colorado, 1889-1896*, p 7.
7. Powers, p 91.
8. Houston Daily Post, 11-19-1899, Image 25, http://chroniclingamerica.loc.gov/.
9. Newsclipping, Houston Chronicle, 4/13/1924. MS08 Emma Richardson Cherry Papers, oversize. Museum of Fine Arts, Houston Archives.
10. RG19 Houston Art League, scrapbook, p 12.
11. RG19 Houston Art League, minutes book, p 19.
12. Unfortunately, the prints and one of her works were destroyed during the 1911 fire in the Rusk School, along with a gift of Copley prints from Jean Sherwood and a painting by Dawson Dawson-Watson. RG19 Houston Art League, minutes book, p 139.
13. Office of the Registrar, object files, Hilda Belcher, *Aunt Jennifer's China, n.d.*. Museum of Fine Arts, Houston.
14. The Art Students League of New York was located at, 28 W 14th St from 1882-87, newsletter, January 1955, Registrar's object files, Emma Richardson Cherry, *Mrs. Henry B. Fall, 1925*. Museum of Fine Arts, Houston.
15. *"What Are Rules For? Modern Show Raises Old Question Anew"*. RG08:01 Public Relations records, newsclippings, January, 1928. Museum of Fine Arts, Houston Archives.
16. *"Years of Spiritual Travail Bring to Mrs. Cherry's Art New Power of Concentration"*, Houston Chronicle, 2/15/1925.
17. MS08 Cherry Papers, oversize clippings.

Endnotes - Emma Richardson Cherry: Houston's First Modern Artist by Randolph K. Tibbits

1. For a study of Cherry's earlier career, including her years in Denver, see Meredith McKee Evans, *A Pioneering Spirit: E. Richardson Cherry and the Development of the Arts In Denver, Colorado, 1889-1896*. (MA Thesis, University of Denver, 2004).
2. Mike Bynum, *King Football: Greatest Moments in Texas High School Football History*. (Birmingham, Alabama: Epic Sports Classics, 2003), 26.
3. James Perkins Richardson, letter to Emma Richardson Cherry, October 23, 1894. The original of this letter is in the collection of James Perkins Richardson II. A transcription appears on the web at http://familytreemaker.genealogy.com/users/r/i/c/James-P-Richardson-ii/WEBSITE-0001/UHP-0022.html accessed November 25, 2012. Though Richardson's middle name was Perkins, after his marriage to Hannah Caffrey he used the name "James Caffrey Richardson" for some years.
4. "Society," *Houston Post*, October 19, 1919.
5. Ibid.
6. Meredith McKee Evans, *A Pioneering Spirit*. 10.
7. Ibid.
8. "An Attractive Studio Closing," *The Kansas City Star*, October 21, 1888, 2.
9. Writing in 1888 to his new wife away in Paris, Dillin said, "There isn't any doubt in my mind that we are pursuing the right course and sometime will be all the happier for our little sacrifices." DB Cherry to ER Cherry. September 8, 1888. Even so, Paris was a long way from home and from him, and he fought against a jealous nature: "… I am uneasy all the time. If I thought you were as indiscrete in Paris as you were in New York I would either arrange to go there or have you return at once. Try little one to look at the evils of that great City. I know them even though I never was there. It is unfortunate for me that I am so well acquainted with the average mans morals." DB Cherry to ER Cherry. February 5, 1888. Both letters in the Cherry Collection, The Harris County Heritage Society Archives, Houston, Texas.
10. Cherry attended Worlds Fairs throughout her life: Paris 1889, 1900, 1925; Chicago 1893, 1933; St. Louis 1904. In addition to the opportunity to see art in the exhibitions that accompanied the fairs, she drew from the visits an appreciation of how art could be exhibited to educate. She applied the lessons learned in her own curatorial efforts.

11. E. Richardson Cherry Papers. Houston Metropolitan Research Center, Houston Public Library. Box 10.

12. Dawson Dawson-Watson, "The Real Story of Giverny," in Eliot Clark, *Theodore Robinson, His Life and Art* (Chicago: R.H. Love, 1979), 67.

13. Dawson-Waston's 1888 oil, *Giverny*, now in the Terra Foundation Collection, and Cherry's watercolor of the same year, *At Giverny(Rue de Giverny)*, in a private collection, depict the same scene, but from a slightly different perspective, indicating that they were painted en plein air with Dawson-Watson to the left and Cherry to the right as they worked.

14. William Gerdts, *Monte's Giverny: An Impressionist Colony* (New York: Abbeville Press, 1993), 33.

15. "The impressionist school, of late so popular, is represented by several fine specimens by Dawson Watson [sic]. They are remarkably clever and as studies of the 'plenair' style will receive much attention." "Many Gems of Art," *Rocky Mountain News,* April 15, 1984.

16. Cecilia Steinfeldt, *Art for History's Sake: The Texas Collection of the Witte Museum*, ([Austin, Tex.] : Texas State Historical Association for the Witte Museum of the San Antonio Museum Association, 1993), 32.

17. Not only did Cherry attend the 1893 Chicago Exposition, she also exhibited paintings in both the Colorado and Woman's Buildings. "For Women," *Rocky Mountain News*, June 23, 1894.

18. Cherry delivered the first of her Fair lectures, "The Pictures at the Fair," on Thursday, October 26, 1893. "Local Notices," *Rocky Mountain News,* October 24, 1893.

19. "Will Be a Whopper. The Big Texas Coast Fair," *Galveston Daily News*, October 28, 1896, 10.

20. "Art Department," *Galveston Daily News,* November 8, 1896. 5.

21. Ruth Richardson, "An Hour In A Gallery," *Houston Daily Post,* November 15, 1896, 19.

22. Emma Richardson Cherry, letter to Dillin Brook Cherry, Taormina , Sicily, February 5, 1910, Emma Richardson Cherry Papers, Harris County Heritage Society, Houston, Texas.

23. *Houston Daily Post*, November 10, 1896, 8.

24. They sailed from New York City on the Red Star Line "Lapland", departing September 9, 1911. In her copy of the passenger list, Mrs. Cherry noted the city of residence of several, though not all, of the other first class passengers. Beside the names of Michael, Sarah and Allen Stein she has written "Paris." The Red Star Line S.S."Lapland" Passenger List, September 9, 191l, private collection.

25. In a 1924 letter to Katherine Dreier, Cherry said of Chillman, "He is a Philadelphian, and they don't always know the New York painters." Emma Richardson Cherry, letter to Katherine Dreier, April 2, 1924, Katherine S. Dreier Papers/Société Anonyme Archive, YCAL MSS 101, Box 8, Folder 218. Beinecke Library, Yale University, New Haven, Connecticut.

26. Breckenridge, Hugh H. (Hugh Henry), 1870-1937. "Letter from Hugh Breckenridge to William Ward Watkin, Oct. 12, 1914." Architecture Department, Rice Institute, 1919-1954, Woodson Research Center, Rice University Library. 1914. http://hdl.handle.net/1911/12902.

27. Dorothy Cherry kept a daily diary of her trip to Europe, which is now in the Cherry Collection at Harris County Historical Society Archives, Houston, Texas. For Sunday, October 13, 1912, she noted: "This morning to the 'Salon D'Automne'. Certainly the new things are queer but interesting. The Cubists – how queer! The *lovely* furnished rooms were exquisite."

28. Emma Richardson Cherry, letter to Dorothy Cherry Ennis, Tuesday 28th [September 28, 1920], E. Richardson Cherry Collection, Houston Metropolitan Research Center, Houston Public Library, MSS 27, box 8, folder 4.

29. Abraham A. Davidson, *Early Modernist Painting 1910-1935*, (New York: Da Capo Press, 1994), 240.

30. *Houston Post*, January 4, 1920.

31. Emma Richardson Cherry, letter to Dorothy Cherry Ennis, Tuesday 28th [September 28, 1920], E. Richardson Cherry Collection, Houston Metropolitan Research Center, Houston Public Library, MSS 27. Box 8, Folder 4.

32. Emma Richardson Cherry Collection, Museum of Fine Arts, Houston, Archives.

33. "Through Dreier's constant nurture and Duchamp's tireless networking, it grew into an elaborate international web of correspondence and exchange among artists who were often introduced to one another through its auspices." Jennifer R. Gross, "An Artists' Museum" in *The Société Anonyme: Modernism for America,*" Jennifer R. Gross, ed., (New Haven: Yale University Press, 2006) 3.

34. Marsden Hartley, postcard to Emma Richardson Cherry, December 1920. Private collection.

35. Katherine Dreier, letter to Emma Richardson Cherry, October 20, 1920, Katherine S. Dreier Papers/Société Anonyme Archive, YCAL MSS 101, Box 8, Folder 218, Beinecke Library, Yale University, New Haven, Connecticut.

36. Emma Richardson Cherry, letter to Katherine Dreier, April 2, 1924, Katherine S. Dreier Papers/Société Anonyme Archive, YCAL MSS 101, Box 8, Folder 218, Beinecke Library, Yale University, New Haven, Connecticut.

37. Art Exhibitions Of The Week. *New York Times*, June 24, 1923.

38. Mary Ellen Bute, "Abstronics: An Experimental Filmmaker Photographs the Esthetics of the Oscillograph, "http://www.centerforvisualmusic.org/ABSTRONICS.pdf Accessed November 29, 2012.

39. Emma Richardson Cherry, letter to Dorothy Cherry Ennis, 1st Sunday in November [November 1, 1925], E.Richardson Cherry Collection, Houston Metropolitan Research Center, Houston Public Library, MSS 27, box 2, folder 5.

40. A large collection of letters from Clemens to her husband, including many written while she traveled with Cherry, are preserved in the Geroid T. Robinson Papers, Rare Books & Manuscripts Library, Columbia University Library, New York. The letters mentioned here are in that collection.

41. "Houston Artist Enjoys Study In Parisian Studio," *Houston Chronicle*, December 27, 1925.

42. Emma Richardson Cherry, letter to Dorothy Cherry Ennis, October 9, [1925], E. Richardson Cherry Collection, Houston Metropolitan Research Center, Houston Public Library, MSS 27, box 1, folder 2.

43. Emma Richardson Cherry, letter to Dorothy Cherry Ennis, October 25, [1925], E. Richardson Cherry Collection, Houston Metropolitan Research Center, Houston Public Library, MSS 27, box 1, folder 3. "Caroline's picture" refers to *Precious Bowl* now in the permanent collection of the Museum of Fine Arts, Houston.

44. "Houston Artist Enjoys Study In Parisian Studio," *Houston Chronicle*, December 27, 1925.

45. Emma Richardson Cherry, letter fragment to Dorothy Cherry Ennis, [caFeb 1926], Emma Richardson Cherry Papers, Harris County Heritage Society, Houston, Texas.

46. Emma Richardson Cherry, postcard to Dillin Brook Cherry(?), [ca March 1926], private collection.

47. "Dean of Houston Painters Counts Day Lost Unless Something Put on Canvas," *Houston Press,* April 16, 1937.

48. Ibid.

49. Emma Richardson Cherry, letter to Dorothy Cherry Ennis, [ca. March 1926], Emma Richardson Cherry Papers, Harris County Heritage Society, Houston, Texas, box 1, folder 10.

50. Emma Richardson Cherry, letter to Dorothy Cherry Reid, [ca. June 1934], Emma Richardson Cherry Papers, Harris County Heritage Society, Houston, Texas.

51. Ola McNeill Davidson, letter to Emma Richardson Cherry, [August 16, 1950], Emma Richardson Cherry Papers, Harris County Heritage Society, Houston, Texas, box 1, folder 6.

52. Randolph K. Tibbits, "Our Little Gallery' of Abstract Art in Houston, 1938," http://www.caseta.org/ourlittlegallery.pdf. Accessed November 30, 2012.

53. Ola McNeill Davidson, letter to Emma Richardson Cherry, [September 1939], Emma Richardson Cherry Papers, Harris County Heritage Society, Houston, Texas, box 1, folder 7.

54. Alexandre Hogue, "Progressive Texas," *Art Digest*, June 1936 (v.X, n.17),18. Texas Centennial Special Number.

55. John Lucas, "Rome: Habitat of American Painters," *Arts Magazine,* February 1966 (v.40, n.4), 41.

56. "The elegant collages by Gene Charlton (1909-1979) are a revelation. Small and abstract, these untitled works from the late 1950s nonetheless seem as powerful as the monumental paintings Robert Motherwell was making in New York at about the same time." Patricia Johnson, "Exhibition Reveals Surprising, Powerful Links," *Houston Chronicle,* April 1, 1991.

EXHIBITION PLATES

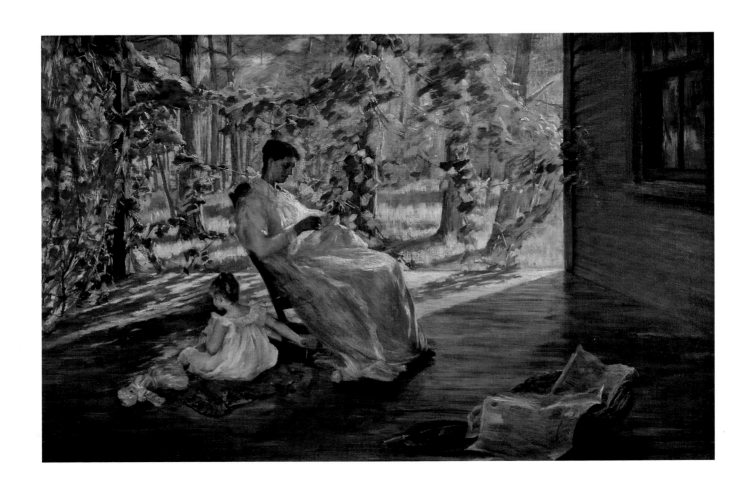

Emma Richardson Cherry
On the Gallery, At the Pines, 1894
Oil on canvas, 24 x 36

Collection of Juli and Sam Stevens

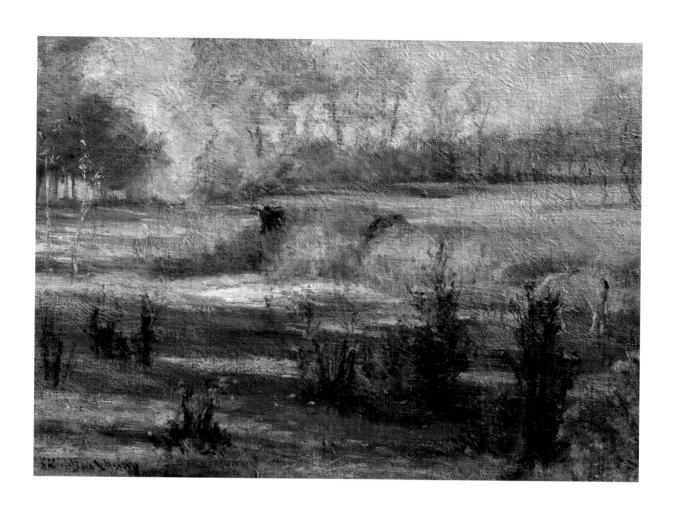

Emma Richardson Cherry
Normandy Fields, 1888/89
Oil on canvas, 12¼ x 16

Collection of Randy Tibbits and Rick Bebermeyer

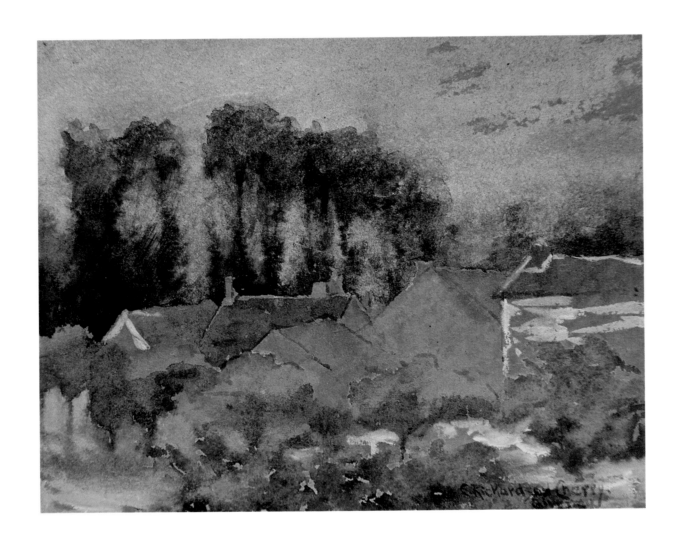

Emma Richardson Cherry
Rainy Afternoon, Giverny, 1888/89
Watercolor, 6½ x 7½

Collection of Randy Tibbits and Rick Bebermeyer

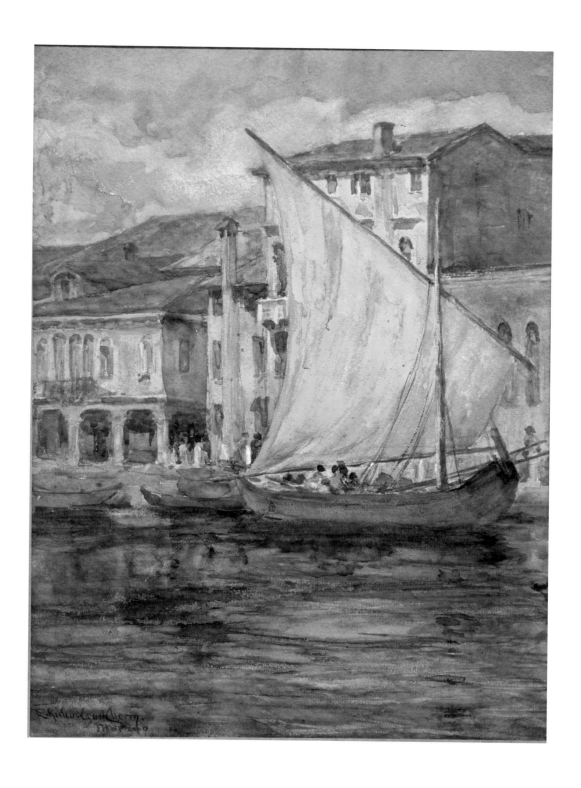

Emma Richardson Cherry
Yellow Sail, 1910
Watercolor, 15 x 10½

Collection of Tam and Tom Kiehnhoff

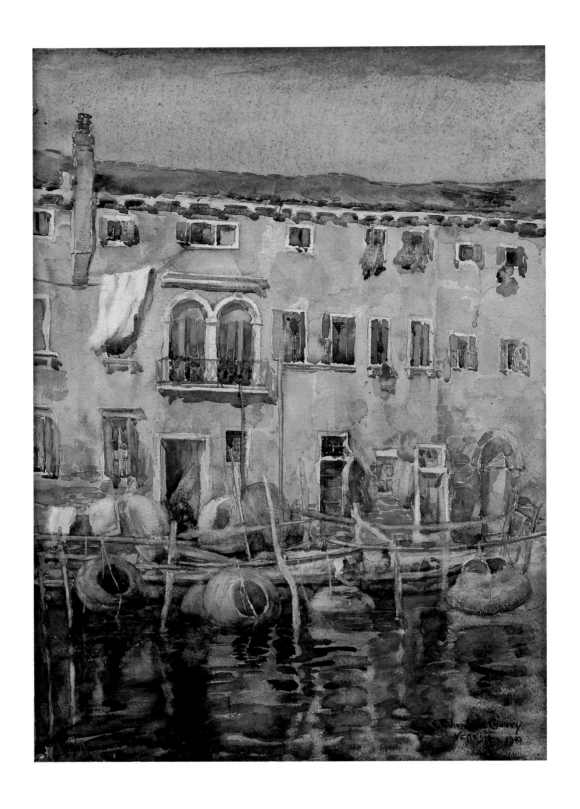

Emma Richardson Cherry
Fishermen's Homes – Giudecca, 1910
Watercolor, 22 x 16

Collection of David Lackey and Russell Prince

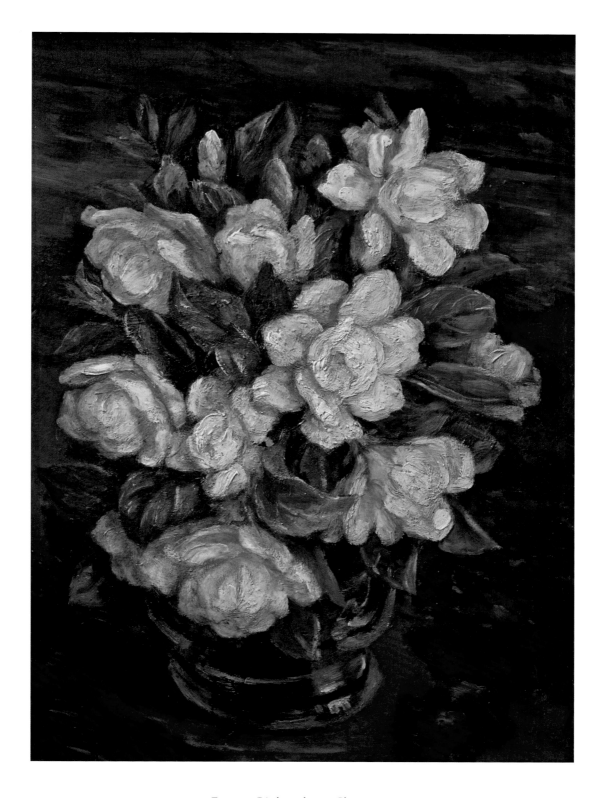

Emma Richardson Cherry
Bouquet of Jasmine, c.1910s
Oil on board, 16 x 12

Collection of Larry Martin

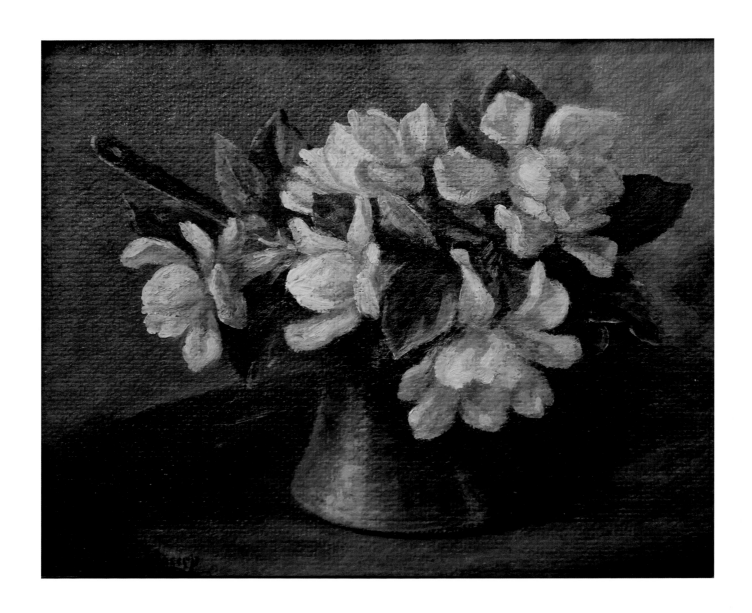

Emma Richardson Cherry
Cape Jasmine in a Copper Cup, c.1910s
Oil on board, 10 x 12

Collection of Randy Tibbits and Rick Bebermeyer

Emma Richardson Cherry
The Alamo, San Antonio, 1911
Oil on canvas , 9 x 12

Collection of James Clement

Emma Richardson Cherry
At Seabrook, 1917
Oil on canvas, 11¼ x 15½

Collection of Sam and Neil Akkerman

Emma Richarsdon Cherry
Sulphorous Pool, c.1919
Oil on board, 20 x 16

Collection of Randy Tibbits and Rick Bebermeyer

Emma Richarsdon Cherry
Dull Day on the Cove, 1920
Oil on board, 17 x 14

Collection of Randy Tibbits and Rick Bebermeyer

Emma Richarsdon Cherry
Dorothy in Blue, c.1920s
Oil on board, 19½ x 13½

Collection of Wade Mayberry

Emma Richarsdon Cherry
Flying Prisms, c.1920
Oil on board, 14 x 28

Collection of Randy Tibbits and Rick Bebermeyer

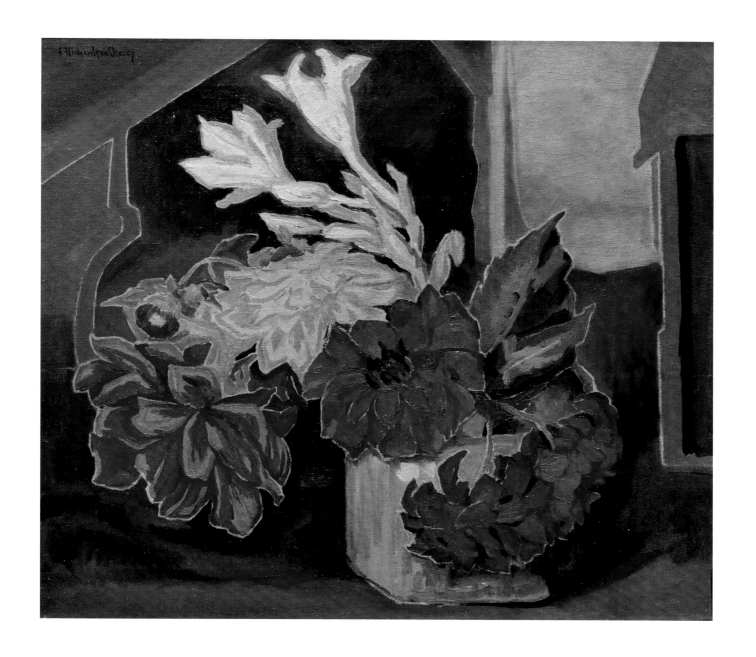

Emma Richardson Cherry
Decoration, c.1920
Oil on canvas, 18 x 20

Collection of Juli and Sam Stevens

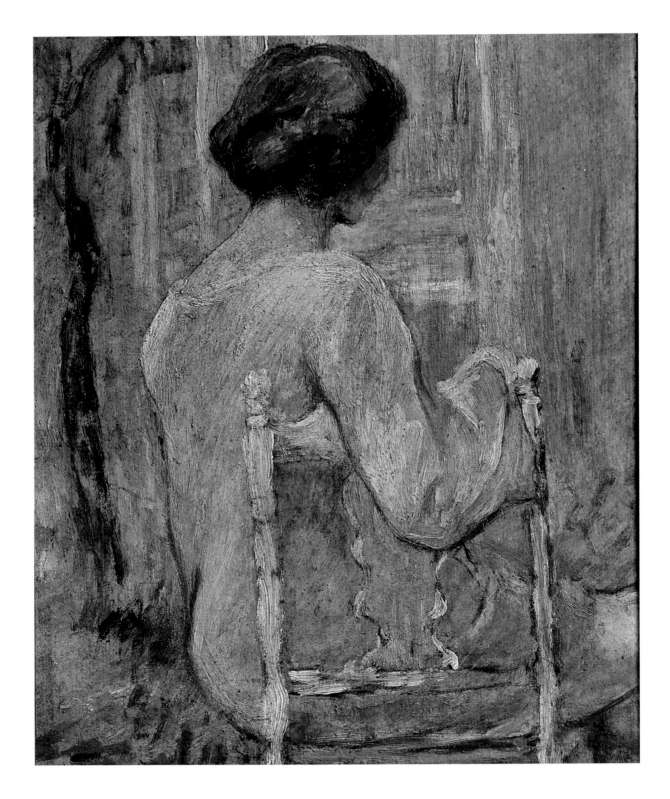

Emma Richardson Cherry
Girl in Yellow, c.1923
Oil on board, 11½ x 8½

Collection of David Lackey and Russell Prince

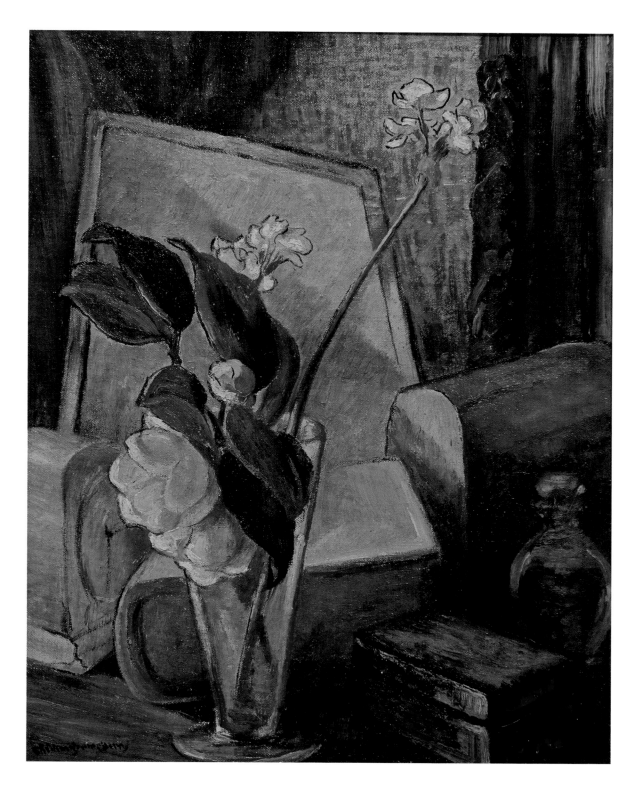

Emma Richardson Cherry
Narcissus in Studio, c.1923
Oil on canvas

Collection of David Lackey and Russell Prince

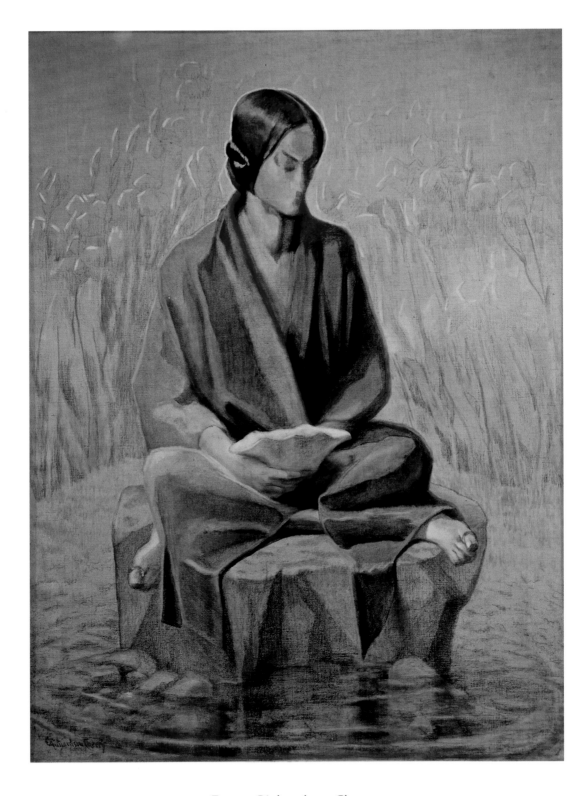

Emma Richardson Cherry
Precious Bowl, c.1923
Oil on canvas, 36 x 26⅛

Collection of Museum of Fine Arts, Houston

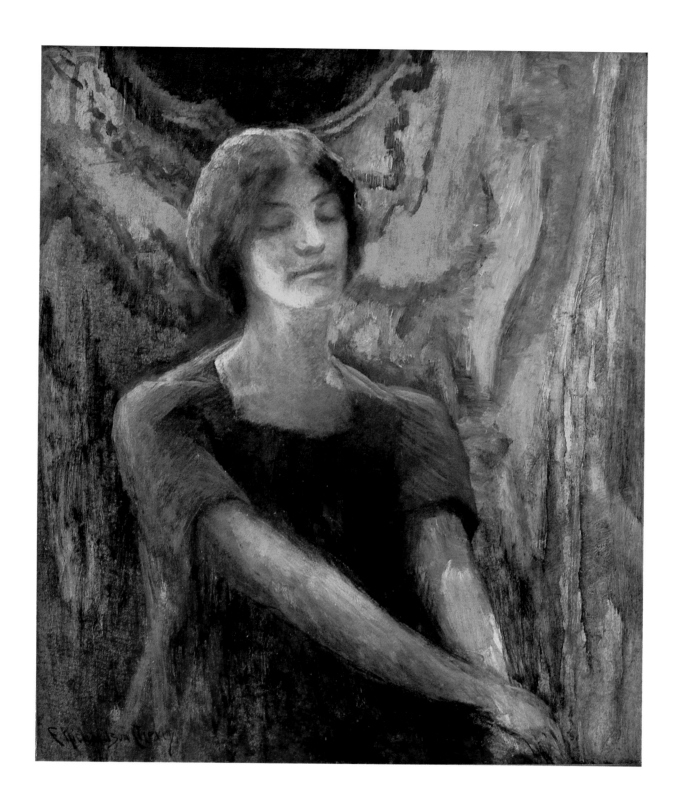

Emma Richardson Cherry
Day Dream, c.1924
Oil on board, 17 x 14

Collection of Sandra and Bobby Lloyd

Emma Richardson Cherry
Padre's Walk, 1925
Oil on canvas, 11½ x 8½

Collection of Jennifer Reid & Zachary Patton

Emma Richardson Cherry
Bridge at Chartres, 1925
Watercolor, 5 x 7

Collection of Tam and Tom Kiehnhoff

Emma Richardson Cherry
Road in Guerande, 1925
Oil on board, 13½ x 16½

Collection of Randy Tibbits and Richard Bebermeyer

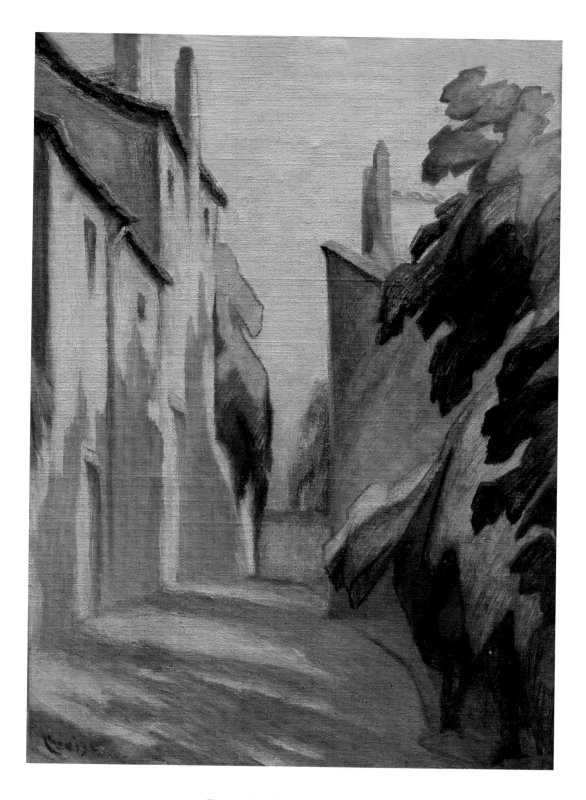

Emma Richardson Cherry
Shadow Patterns, 1925
Oil on board, 19½ x 13

Collection of Randy Tibbits and Rick Bebermeyer

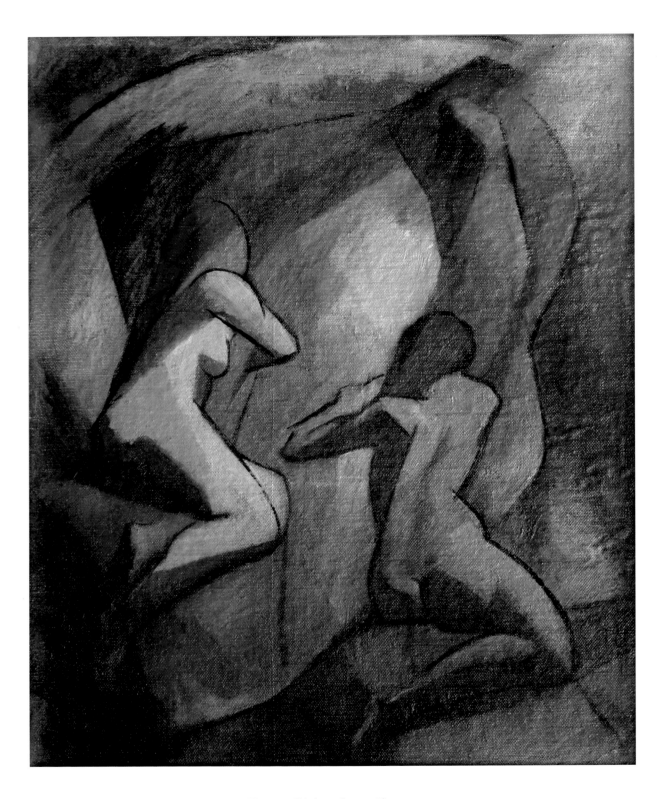

Emma Richardson Cherry
Arrangement, 1925
Oil on board, 17¼ x 14

Collection of Randy Tibbits and Rick Bebermeyer

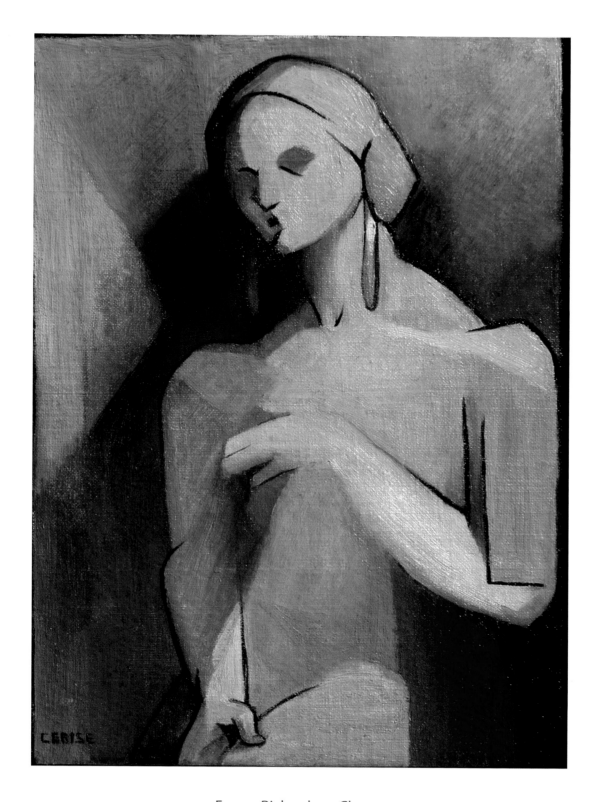

Emma Richardson Cherry
Study in Compositional Spaces, 1925
Oil on board, 12 x 8½

Collection of Randy Tibbits and Rick Bebermeyer

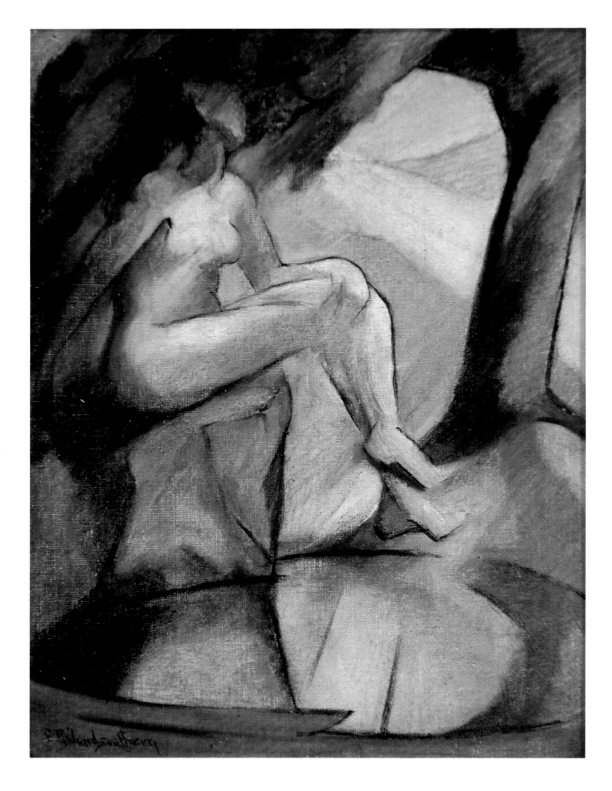

Emma Richardson Cherry
Pan's Pool, ca1925
Oil on board, 12 x 9

Collection of Jennifer Reid & Zachary Patton

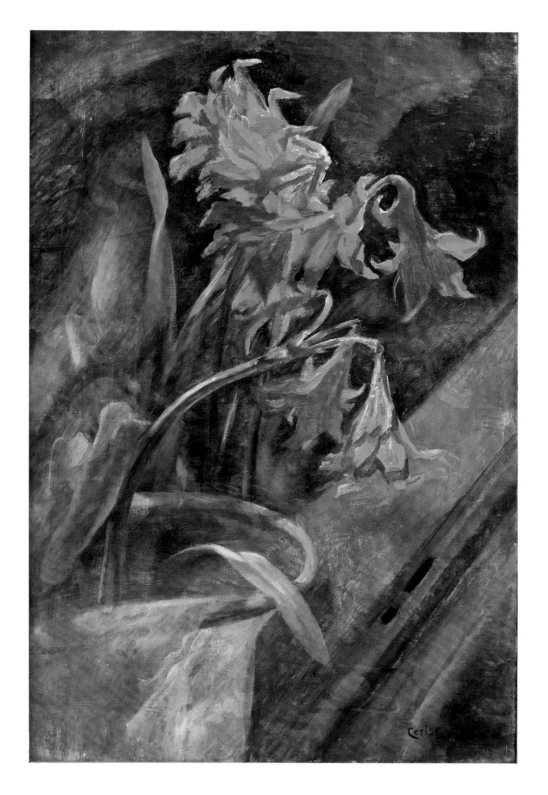

Emma Richardson Cherry
Interpretation in Red, c.1925
Oil on canvas, 27¾ x 17½

Courtesy of William Reaves Fine Art

Emma Richardson Cherry
In the Beginning [Esperson Building], 1925
Oil on canvas, 36 x 36

Collection of Bill & Linda Reaves

Emma Richardson Cherry
Valldemosa, 1926
Oil on canvas, 19¾ x 23

Collection of Cynthia and Bill Gayden

Emma Richardson Cherry
Alpine Fantasy Fribourg Switzerland, c.1928
Oil on canvas, 36 x 26

Courtesy of David Dike Fine Art

Emma Richardson Cherry
Across the Valley, 1929
Oil on canvas, 20 x 24

Collection of Randy Tibbits and Rick Bebermeyer

Emma Richardson Cherry
Early Morning in August/Spider Lilies and Crepe Myrtles, c.1931
Oil on canvas, 35½ x 25½

Courtesy of William Reaves Fine Art

Emma Richardson Cherry
Major Reid, 1936
Oil on canvas, 40 x 28

Courtesy of William Reaves Fine Art

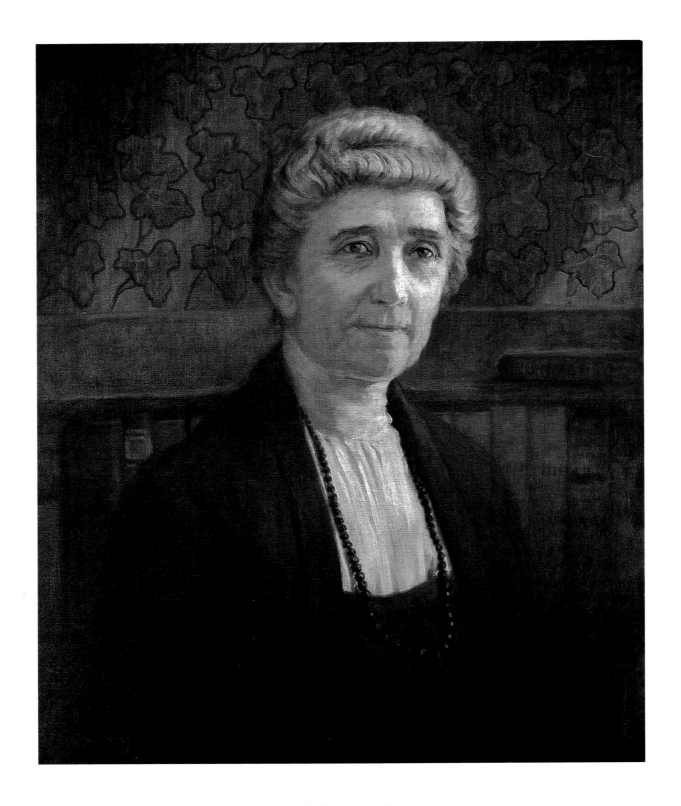

Emma Richardson Cherry
Portrait of Mrs. Looscan, 1936
Oil on canvas, 30 x 24½

Collection of the Houston Public Library

Emma Richardson Cherry
Red Oaks House Randolph Field, c.1937
Oil on board, 8 x 10

Collection of Nancy & Otis Welch, Keller, TX

Emma Richardson Cherry
Patio at Randolph Field, 1937
Oil on board, 30 x 25

Collection of Nancy & Otis Welch, Keller, Texas

Emma Richardson Cherry
Buffalo Bayou – Flood Control, 1937
Oil on canvas, 29½ x 39½

The Bobbie and John L. Nau Collection

Emma Richardson Cherry
Nichols-Rice-Cherry House at Night, n.d.
Oil on canvas, 30x24

Collection of The Heritage Society

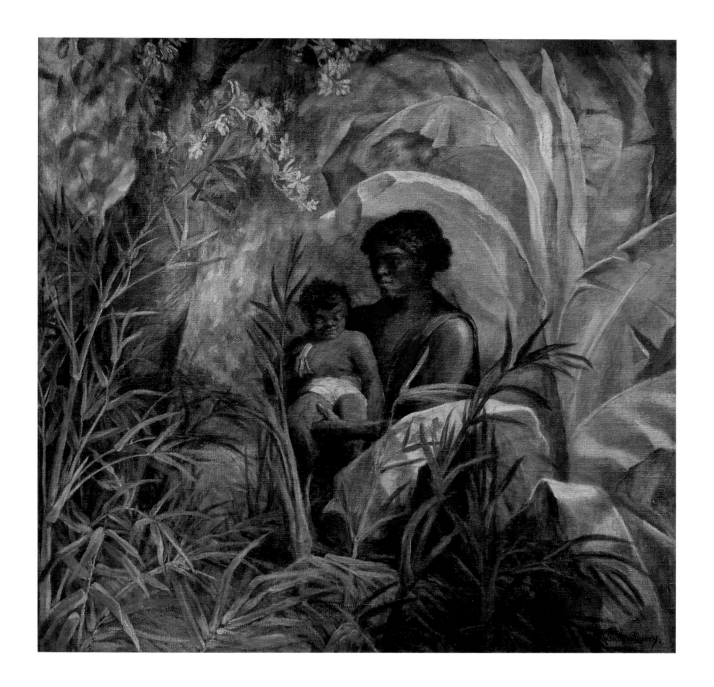

Emma Richardson Cherry
Deep South, c.1937
Oil on canvas, 36 x 36

The Torch Collection

Emma Richardson Cherry
Miss Nellie, n.d.
Pencil on paper, 23½ x 18

Collection of The Heritage Society

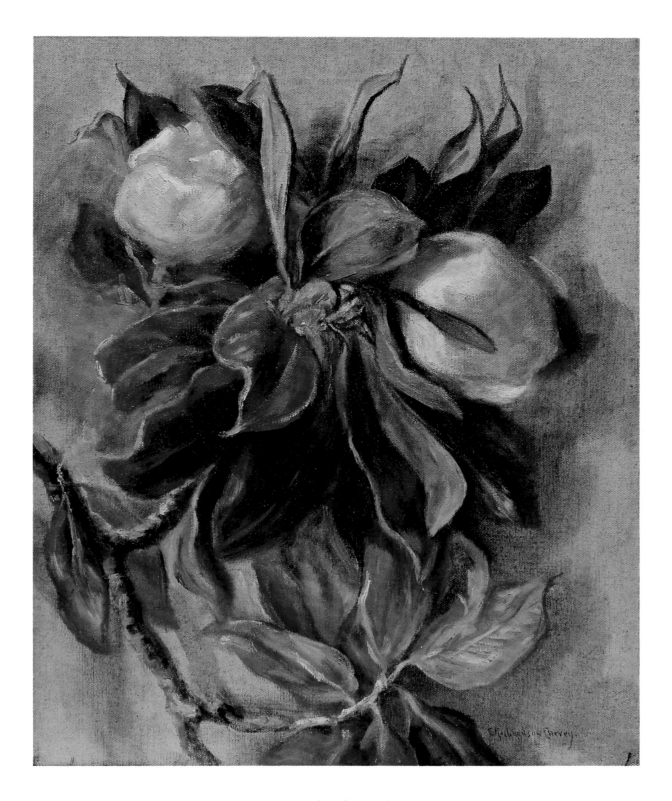

Emma Richardson Cherry
Untitled (Magnolia), n.d.
Oil on canvas, 19 x 15

Courtesy of William Reaves Fine Art

Emma Richardson Cherry
Bluebonnets, n.d.
Oil on canvas, 17 x 21

Collection of The Heritage Society

Emma Richardson Cherry
Beacon and Fog, Randolph Field, c.1940
Oil on canvas, 35½ x 25¾

Courtesy of William Reaves Fine Art

Ola McNeill Davidson
Hog Waller, c.1928
Oil on canvas, 30¼ x 25¼

The Bobbie and John L. Nau Collection

Theonis Contreras
Untitled (sketches), 1932
Charcoal, 4½ x 4½

Collection of Mr. and Mrs. Romero

Forrest Bess
Mission Concepcion, 1936
Oil on board, 12 x 9

Collection of Randy Tibbits and Rick Bebermeyer

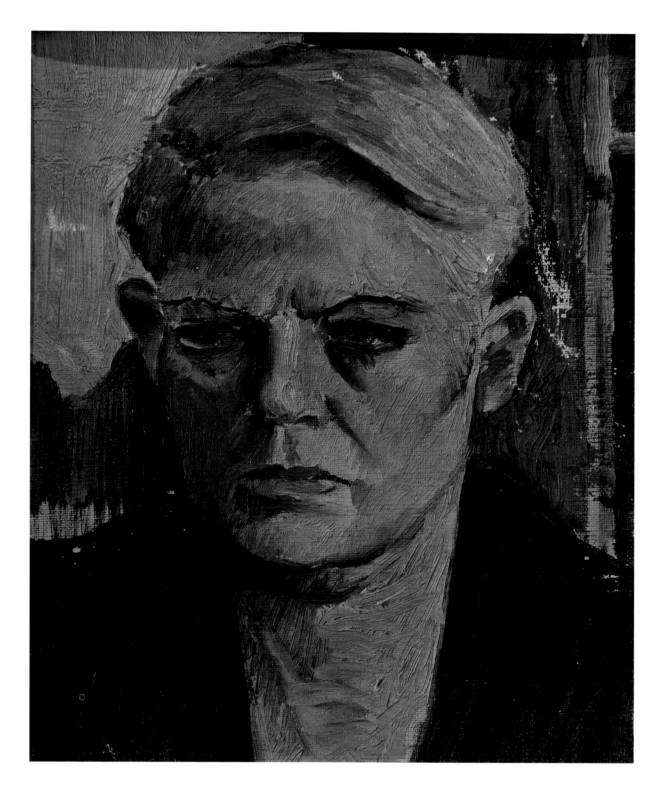

Ola McNeill Davidson
Self Portrait, c.1937
Oil on canvas, 8 x 8

Collection of Rie Davidson Congelio

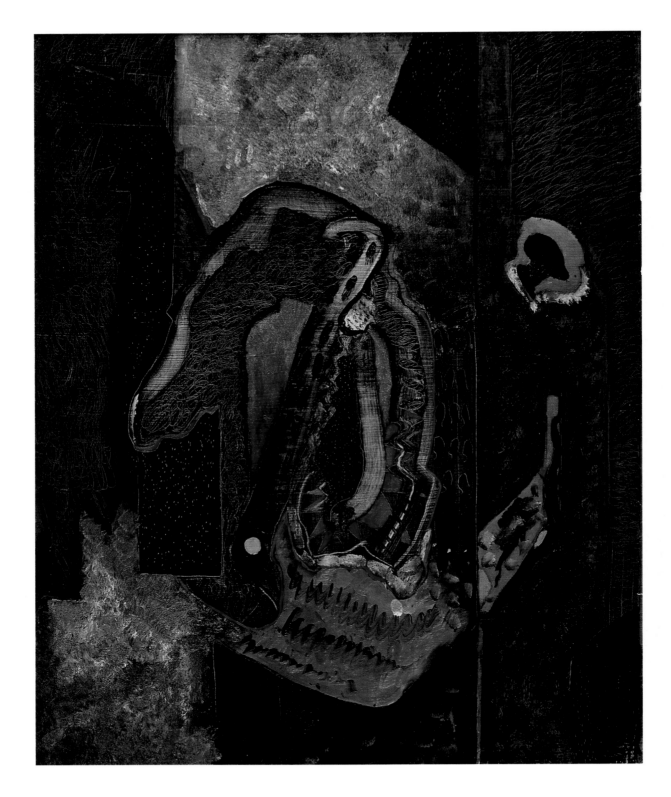

Robert Preusser
Nucleus, 1937
Oil on board, 16 x 20

Collection of Earl Weed

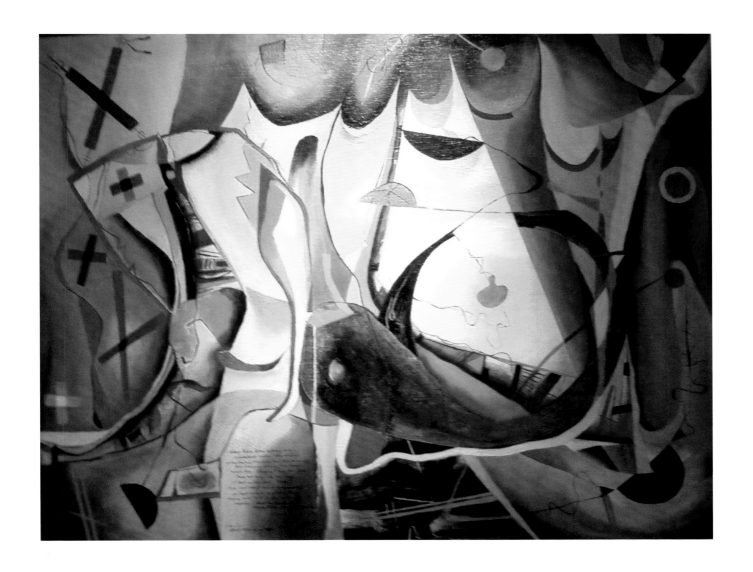

Frank Dolejska
Blue Whale Two, 1938
Oil on board, 23 x 29

Private Collection

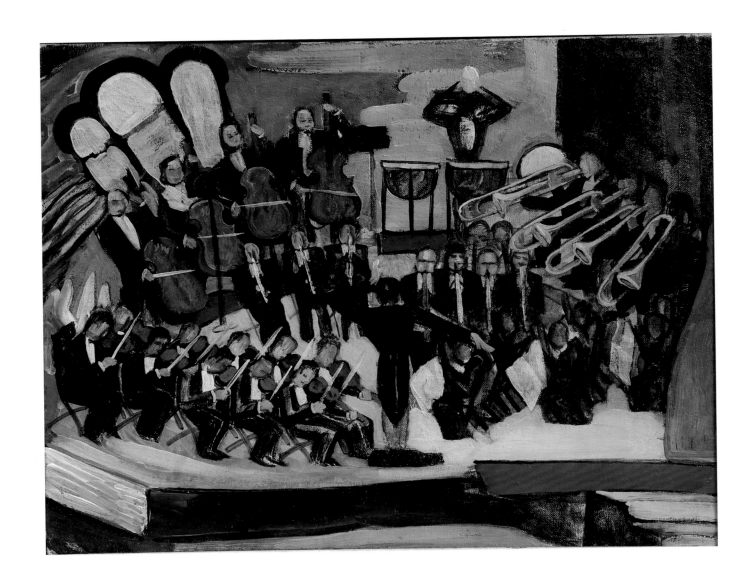

Carden Bailey
Symphony Orchestra, 1940
Oil on canvas, 11 x 14

Collection of Randy Tibbits and Rick Bebermeyer

Gene Charlton
Eggplant, 1942
Oil on canvas, 10 x 8

Collection of Museum of Fine Arts, Houston

Maudee Carron
Magic Script #1, 1944
Watercolor, 8½ x 11¼

Collection of Randy Tibbits and Rick Bebermeyer

Nione Carlson
Hungar, ca 1951
Oil on board, 24 x 18

Collection of Randy Tibbits and Rich Bebermeyer

Stella Sullivan
Reflections in a Glass Door, 1967
Oil on canvas, 30 x 24½

The Collection of Houston Public Library